天與地的現象　七等生藝術集

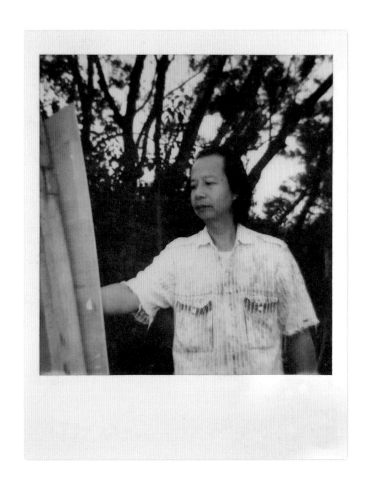

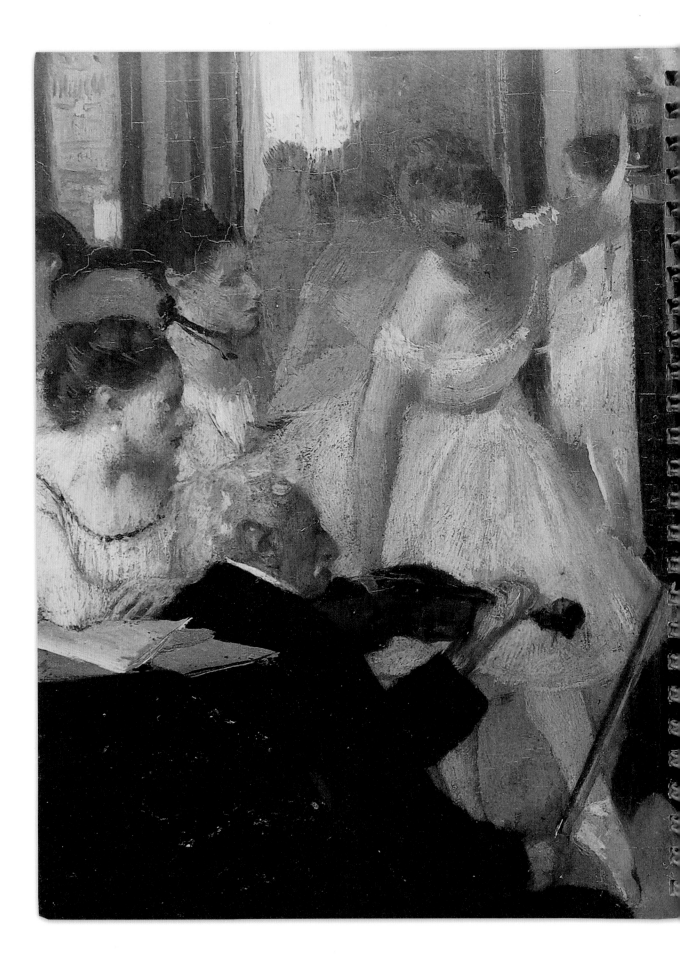

**13**
SUNDAY

自然是我的主人

我是它的孩子.

**14**
MONDAY

當我注视它

**15**
TUESDAY

它每刻持示我过来

它是什左和我是什左

**16**
WEDNESDAY

它仍一些々的外表

正在使我認知我仍所刻存左

**17**
THURSDAY

我若是继续看着它

我仍生命無疑会延续下去

**18**
FRIDAY

探索我就能同意我的情感和心里

我走它的面前手舞足蹈

我就能呼吸到它揪出来的气息,

**19**
SATURDAY

這气息同抗挭成我的欲望
身体

---

**DEGAS,** *The Dancing Class*

Oil on wood, 7¼" x 10⅝", about 1871.
Bequest of Mrs. H. O. Havemeyer, 1929, H. O. Havemeyer Collection        29.100.184

Degas knew how to use his brush to describe freely, yet with wonderful
precision, the play of shadows on a face, the glint of a pearl earring, and the
gracefulness of a black ribbon—a striking accomplishment on a canvas of such
small proportions.

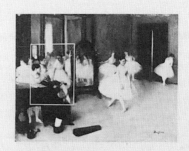

# April

**20** SUNDAY

我描绘它们同时也在勾勒我自己的样子，
因为它的意志充满在我的心内
它的样子被画在纸上就等于是语言，
这语言说的是它才对都是我自己。

**21** MONDAY

**22** TUESDAY

*Passover Begins at Sundown* **23** WEDNESDAY

**24** THURSDAY

**25** FRIDAY

**26** SATURDAY

## MONET, *Apple Trees in Bloom*

Oil on canvas, 24 ½″ x 39 ⅝″, 1873.
Bequest of Mary Livingston Willard, 1926

26.186.1

This view of blossoming trees was painted in Argenteuil, northwest of Paris, in the early 1870s when the village was a favorite gathering place for the Impressionists. Monet captured the pastel colors and the clear light of spring by using a lighter palette and touch than before.

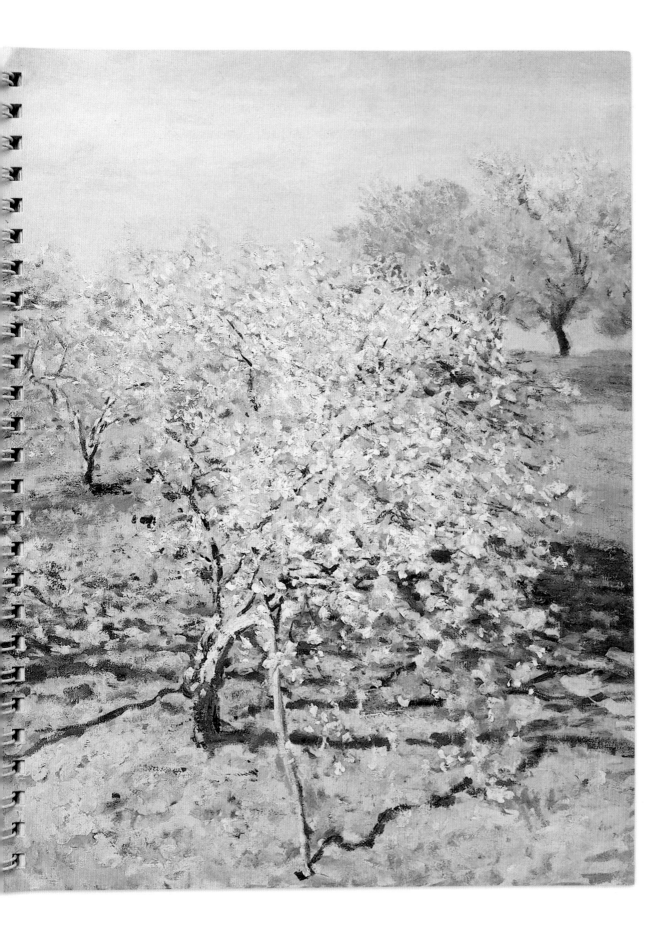

# 遲來的領會 - 給七等生

（一）　讓我們仰望星辰，注視著它們細小而銳利的光輝；
　　　　我們不是最後的人類。

<div align="right">－七等生〈維護〉</div>

懷拙找到了我，要我為他父親遺下的畫作寫幾句話。電話裡，我卻忍不住
要向他談及我初見七等生時的驚詫的感覺，怎麼會有這樣快樂又這樣放得
開的人！

應該是我在台北師範藝術科一年級的下學期了吧？偌大的學生食堂裡，午
餐快結束了，突然有歡笑聲從食堂的一側傳過來，而且越來越高昂興奮，
所有的人都循著哄笑和鼓掌的聲音望過去。原來是一位比我們高班的男
生，站在木質大飯桌的中央，作勢挺身，高舉雙臂旋轉，跳起舞來。那舞
步有點像我們當時略知的西班牙民間舞蹈，舞者身形瘦削，跳起來又極有
彈性，充滿了喜悅的感覺，自由自在……

但是之後的記憶就模糊了，是教官吹了警告的哨子，還是直接過來訓斥？
反正真正的後續情節是要等到暑假之後，新學期開始的時候，才知道這位

舞者是因為同班同學抗議學校的伙食太差，有人把餐桌清空之後，他一躍而上，跳起自己的單人舞來，因而觸犯了校規。

但是，這懲罰怎麼是留級一年，降到我們這一班來呢？

一直不明白的事，要懷拙來告訴我。是他的姑姑，也就是七等生的姊姊去求朋友幫忙，請教育廳還是什麼教育機構的人出面，才把原先的「開除學籍」改為「留級」。

於是，我們就變成了同班同學。

可是，那樣年輕的我們其實是處在一個充滿了戒心和疑慮的時代裡，總要將每個人分類，非黑即白的對立。如今回想，當年即使是站在講台上的牧者，恐怕也是身不由己吧？也是和羊群一起，被困於荊棘之地。

於是，那樣年輕的我們相聚於同一間教室，卻難以相識，更無從相認，在其中有多少渴望星輝來引領的靈魂？

可是我記得，有一次，這個獨來獨往的新同學，從日光斜斜照進的長廊上走過，向教室內的我們，投以匆促的一瞥。他的眼眸色淺而透明，還帶著含有些微善意的憐憫……

（二）　我的寫作一步一步地在揭開我內心黑暗的世界，
　　　　將我內在積存的污穢，一次又一次地加以洗滌清除。
　　　　我的文字具有兩層涵義：
　　　　它冷靜地展示和解析各種存在的現象，並同情地加以關愛。
　　　　　　　　　　　　　　　　　　　　－七等生〈我年輕的時候〉

而七等生在 1992 年 11 月，由欣賞家藝術中心出版的一本畫冊裡，在自序中有言：「余自小喜愛音樂和繪畫，不料學校畢業後踏入社會工作，卻走進文學創作之路，三十年來歲月，顛沛流離，只得溫飽。退休後，重拾童年的喜悅，顫抖地握著畫筆，只是為了排遣這年邁的生活罷了……」

這些言詞中似乎是一種「退讓」。可是，在這本畫冊裡。與他的文學創作相對照，七等生大部分的畫作卻充滿了熱烈飽滿的色光，透露出畫者心靈與大自然相契合時那種滿滿的感動，是一種生命內在自發的感動。

我想，在當時，握著畫筆的七等生，選擇了描繪的對象，用的是重筆和重彩，毫不受綑綁地自由揮灑；那生命力的旺盛，那渴望訴說的強烈，是滄桑歷盡之後方能重新構築的童年喜悅，應該是這一個階段裡的畫作最最可貴之處吧。

懷拙給我參考的資料不多，這一本舊畫冊裡的畫作當然都是 1992 年之前的作品。而七等生與我雖然在中年的時光裡有過一段非常愉悅的因文學生活而重新認識的交往，為了鼓勵我，我的第一本書《畫詩》由皇冠出版社出版之後，他還寫了一篇大約有一萬字的長文評論，發表在聯合報副刊。但是，在他晚年退休之後，我就沒有能夠再見到他了。因此，對他後期的的繪畫作品，我沒有絲毫線索，不知從何寫起，心裡十分不安。

幸好，幸好在今年三月剛出版的《文訊》雜誌裡，讀到蕭義玲教授提供的，她與晚年的七等生通信時，作家的來函以及寄贈的畫作，給了我非常重要的提示：原來，從晚年退休初期的油畫作品那種迸發式的落筆，逐漸安靜了下來，因而，那幾幅從 2013 到 2014 年間的單色林木素描，尺幅雖小，七等生卻是以一種安定從容的筆觸表達，非常奇妙地呈現出一種音樂性的律動，幽微蒼茫，幾乎就等同於他的文學作品中，不時隱約浮現的詩意背景了。

感謝蕭義玲教授提供這幾張七等生晚年的畫作，才讓我們明白：每個個體與生俱來的創作天份並非只有單一的來源。而且即使七等生不無遺憾地表明，他在三十年的文學創作裡似乎放棄了自小喜愛的音樂和繪畫。其實，在他的文學作品裡，在許多隱藏著的角落之間，音樂和繪畫給過他的滋潤，如影隨形，從來也沒有放棄過他。

是的，這是一種「潤物細無聲」般的難以察覺的安慰和引領。幸好，幸好創作者留下了痕跡，讓我們得以相信，並且感受到「滋潤」的可能。

（三）　真正屬於優秀的好作品，除了被察覺到作者心脈的跳動外，

再沒有其他更重要的意義。

如果在文字中有什麼了不起的涵義的話，

也是會為時間淘汰而腐朽的意義。

而心脈的跳動才真正帶有感染性……

－七等生〈文學與文評〉

懷拙寄來一套七等生的「文學卡片」。是作家拍攝的黑白風景，加上他自己書中的一段文字。我從其中選了三則，放在這裡。

原本以為是七等生選的。我還對懷拙說，創作者自選的段落常常是他思想的核心。不料，懷拙這樣回答我：「這是父親晚年後段的日子裡，我替他設計的卡片。攝影作品和文字，也是我慢慢替他挑選出來的。」

在電話的這一端，我心中瞬間充滿了溫暖的波動。是的，再沒有其他更重要的意義了。

如果，如果，在長長的一生之後，一個渴望自由，不受綑綁，藐視被分類的創作者，能夠得到他的孩子的諒解甚至是更深層的了解的話，那麼，作為父親，應該是再沒有比這更為重要的意義和收穫了。

# 從叛逆自覺的初衷到藝術證道

劉懷拙

在我們曾經年輕的記憶裡，不乏有存在某一刻會想將自己激動的拋向這廣漠世界，將此時飽滿的心緒或奇想奉獻與展露出來，這神聖的時刻或許不亞於初戀告白的美好光輝，可惜這往往也是青年尤其是傾向創作之路者逐漸瞭解現實主流及權力平衡下，邁入折翼或漫長旅程的開始。七等生在1962年起初以數篇投稿短篇展現獨特的文體而獲注意，但及至爭議小說〈我愛黑眼珠〉的發表遭到主流學界洶湧的批評聲浪，更有文壇人士在議論中憤而對其唾沫於臉上，而七等生也任其緩緩流下、不發一語。

天性富於敏銳感性的創發表現，卻不見容於當時封閉的文化意識型態，純然大膽突破的思維只會被視為對社會有害的叛逆異端，相較於向來鼓勵創新標誌獨特旗幟的藝術圈，七等生恐怕未能料到文壇當時僵固立場竟如此這般，原本就學於師專藝術科的七等生所嚮往的是自由揮灑想像的藝術世界，可從1968年他於住處所繪的實驗畫作，以色塊線條灑脫勾塗極簡的意像之作〈布馬素描〉（展覽現場陳列）可窺見其感知的現代主義風格。他雖心性更喜往藝術發展，可是已婚的養家育子重擔讓他沒有太多選擇，只能歸鄉教書謀生，然而被外界驅趕的叛逆卻已引發藝術性靈的自覺，他持續以文字來對抗所有視他為異端末流的社會環境，以作品來證明他心目中理想的文學形式是可以不自限於目的性而達成人性更深層的慰藉與啟示的。

10

首先寫作是為要保全自我的記憶且一併對世界的記錄，把我與本來是混在一起的世界試圖分開來，所以筆名對於我，是我對生活中普遍的一切要加以抗辯，尤其在我生活的環境裡，他們幾乎是集體地朝向某種虛假的價值的時候。

            —— 七等生《五年集》後記

1977 年七等生的第一套小說全集十冊出版了，在不到 40 歲的年紀，七等生以非常人的速度完成了似乎是一位純文學創作者的極限，為何他有這樣爆炸性的書寫能量？只有他自己能解釋，彷彿是當時周圍社會的所有虛假現象令他窒息，他非得找尋一個出口來表達他心中另一面的真實世界不可，而這只能在他的小說中完成，他大部份的小說形式並非以寫實故事進行，而是創造了像是寓言般的尖銳人物與現實社會摩擦、衝突或受難，因為時空的模糊而更像是夢中的造境，然而予人的感受卻是真實的，中篇小說《精神病患》就有如卡夫卡小說中的夢魘壓迫，七等生以他的無數個夢或說是幻境來塑造心中認可的更高的真實價值。長篇小說《削瘦的靈魂》（原名：壞孩子）裡面記錄了主角武雄在師院窒悶體制下的一段青少年灰澀狂歌，此時年屆不惑的七等生已能用著藝術的技巧俯瞰彷如過去自己的叛逆身影，他毫不保留的書寫主角對繪畫與音樂的喜愛，就如任何一個尚未知道藝術為何物卻已然被其擄獲的天才一樣。他亦在日後的散文〈我年輕的時候〉談到對音樂的知識和對繪畫技巧的認識，這二者成為他發展文學的踏腳石，永遠賦給他在文學的世界裡具有美感的質素，永遠具有聲音的格律和動人的形姿，從而產生了他個人的真正風格，這亦是他能卓然成為文學大家的重要原因。

七等生小說裡擅長營造的心象氛圍與如幻似真的事物向來為評論者所津津樂道，在直覺上似可對映到印象派或感情更為尖銳的表現主義畫風上面。他對圖像創作始終心念不忘，所以在 1980 年暫時停筆且設立暗房工作室，開始嘗試以攝影來呈現他所見的現實，於是從 1985 年發表的《重回沙河》攝影札記可看到一系列超脫當時紀實攝影之外的黑白原創攝影，內容可初見他設想寓含更多喻意，但離理想感覺距離仍遠，爾後便少再嘗試。這個時期的重大意義是他對藝術思考的沉澱整理，從表現的技巧形式到形而上的思想意義，他屢屢從生活現實中淬練觀照自我，形成如老莊哲學及克羅齊美學裡的視野體悟。在 1983 年他赴美參加國際作家工作坊之後，漸有

國外學者注意到他的文學寫作，而紛有來自美、法、義等國的學者研究發表論文或譯本，國內則遲至 1990 年才有廖淑芳教授（時為研究生）所寫的第一篇學院研究七等生的碩士論文，其時已離七等生初篇發表過了 28 年。不過在《重回沙河》之後的七等生已瞭解對於藝術的追求就是他證明渺小的人類欲接近真理所迂迴前進的求道記錄，對於外界的毀譽亦不再上心，在《譚郎的書信》出版後便不再有迫切寫作的欲望，他在書中藉書信形式娓娓道出他只願做為一個全然奉獻於善美的藝術家，他剖析自己內在隱微處的思緒顫動，就像在演示人類所能到達自我靈魂的最遠深度。

　　…………只要記住世上的人類有這樣的一個類型，它是存在的，
　　在人類一切行為外表的內裡，有這樣的一種靈魂就是了。

　　　　　　　　　　　　　　　　　　── 七等生《譚郎的書信》

　　在 1989 年七等生於教師退休後，終能卸下生活擔子迫不及待的擁抱他原初熱愛的繪畫藝術，當初狂飆意欲的叛逆青年如今已跋涉過現實顛簸的滄桑，他已領悟藝術的真理在文字為 " 詩 "，在畫作便是能與自我意識相融為同一情感脈動的 " 意念寫真 "，是以在他所留近百幅的畫作裡挑選的 61 幅作品中（已編入畫冊），我們的確能感受到如同他自己所寫的詩作裡相彷的物象及律動觸感。

　　「 突然我的心靈招喊著
　　　　要我向一個鵠的走去
　　　　秋日的陽光高耀如火輪
　　　　寂寥而偏僻的灰色小路
　　　　………………………………
　　　　於是我悄悄地進入木麻黃樹林
　　　　僅僅是一片寧謐就是我的聖地
　　　　我站在沙丘的柔軟高頂肅立凝注
　　　　那聲音在白波的發生和幻滅間形成 」

雖然在七等生創作早期即有文壇耆老稱其為文學使徒，然而他所沒有看到的是七等生最後竟於藝術上行得更遠，始終具有的是藝術家的靈魂，或許更適合以藝術使徒名之。時代會召喚叛逆者，讓他為受到可鄙現實封窒的

人類靈性敲開一扇亮光，七等生自叛逆起始，但他走上的是以藝術找尋真理之路，他曾說過大自然是沒有辦法模仿的，臨摹的寫生亦是徒勞，人們所能接近自然的最大價值便是不斷的在每一次靠近時重新發現自我。他把這用意念寫真的觀念體現在畫作裡，其中的山、海、林樹無一不是現實時空與自我的交融變形，皆已然成為一種更真實的精神現象了。

　　七等生以文學及繪畫二種藝術形式將其畢生對人性內在本質的探索過程完整記錄下來，我稱之為 " 證道 " 而不名為 " 悟道 "，因為他在最後現身的紀錄片裡說過：**我活著就是一個真理……我每天都還在多瞭解一點我到底是什麼？** 誠然真理並不固存於同一形式，七等生如同浮世繪大家北齋至臨終前仍覺得有未竟的創作奧秘一樣，他們將僅有的一生奉獻給更高的存在且深遂完整的成為藝術的化身。願以七等生贈予同學好友席慕蓉的一段箴語作為每個世代同樣試圖創作或已然在此道路上的人同勉：

「 人生唯有心中願望的一條路，而善意不尋旁門左道，
　　誠心就是創作的正途。

　　　　　　　　　　　　武雄
　　　　　　　　　　　　1980.10.22 于通霄 」

七等生與劉懷拙

# 樹的秘密 —— 我所知道的晚年七等生

蕭義玲

我善於選擇我需要的事物……我的繪畫像是隨隨便便畫的，其實其中找不完有意無意自然存在的意象。

—七等生書信，2014.7.30

寫作歷程來看，自《思慕微微》（1997）發表後，2010 年獲國家文藝獎，以及 2012 年出版精選集《為何堅持？——七等生小說精選集》，台灣文壇就不再接收到七等生寫作的相關訊息了。然而面對這麼一位性格鮮明卻避居於世，且帶著神祕色彩的小說家，更引發讀者好奇：他的晚年做些什麼？

## 他仍在寫作

我於 2012 年，在《為何堅持？——七等生小說精選集》發表會上初見七等生，直至 2020 年底作家離世，八年間書信，七等生每每在信中提及他的生活、記憶，以及對藝術的看法。千絲萬縷，我想，或能從他對外公布的全集後不再寫作的那個起點說起。我問詢：何不繼續書寫？他如此回答：

我的停筆已經是十年前的事了。我不會就形式上用小說來表示我又重新寫作了。（2013.1.22）

而後我再次提到希望看到他的「文字」寫作時，七等生仍答：

退休後幾年的畫作有如我的文字作品，充滿著個人對這世界的記憶。Anna（案：馬勒女兒）所說的 the universe makes sense 在我的理解就是這個意思。（2013.11.15）

信末並附上與美漢學家墨子刻（Thomas A. Metzger）通信時，漢學家的台灣妻子阿芬回台灣時所照的照片，七等生喜歡這張照片，因著：「背光的囂張樹景、暗啞的綠禾，不知往何處的灰路。」最後道：「......but there is beauty in the ugliness」。醜陋與美，暗與光，是的，生活在這裡。是以若問，晚年的七等生在做什麼？我會回答：我所知道的七等生，仍在自己的藝術活動中，不以文字，而以畫。他仍在寫作，甚至是更純粹更直觀的寫作。

## 「世界的表面看來平靜而美麗，但我的內心很不安寧」

也許我們過度聚焦於七等生文學，而忽略了他的繪畫。時間歷程看，退休前，七等生便在做專心繪畫的準備，1994 年曾開設畫鋪子，舉辦畫展，雖然時間短暫，但綜觀其一生，「繪畫」可能更是他藝術世界的更核心、更精粹表達，或至少是貫穿在其書寫中，與文學相互依存的一面。若溯源更早，早在〈我年輕的時候〉一文中，七等生便自道繪畫之於他的意義。文中，七等生說道他的藝術啟蒙：年輕時（23 歲），時任礦區九份小學教師的自己「非常的寂寞和孤獨。」因為：「世界的表面看來平靜而美麗，但我的內心很不安寧」。一天路過礦工休息處，一位躺在長板凳，望著頭頂樹葉華蓋間的葉隙白光，手擺出管窺動作，且發表著心得的矮胖男人引起他的注意（即礦工畫家洪瑞麟），如此身處寂寥卻怡然自得的樣貌觸動了他。又一段繭居歲月後，年輕七等生發現自己有了另一雙眼睛，得以看到自己在時間的行走，更驚奇地是可以說出和別人不同的語言，於是落筆：「已經退役半年的透西晚上八點鐘來我的屋宇時我和音樂家正靠在燈盞下的小木方桌玩撲克。」（〈失業、撲克、炸魷魚〉），「小說家七等生」誕生了。

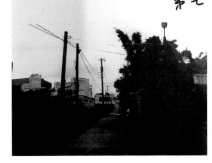

2013 年 11 月 15 日七等生信件原本

墨子刻妻子阿芬贈與七等生的相片

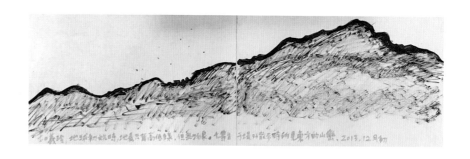

繪畫、洪瑞麟事件,讓我們對七等生的文學與語言之理解,有了新的焦點,甚且可能是更具創造性的理解。從洪瑞麟到七等生,說明了藝術家的語言不在表象現實,而在與自然宇宙的真正遇合,一種自體的真正感覺。七等生的文學語言,根源於一種特殊且自我的管窺與看視,繪畫是視覺更直接的表達,如〈我年輕的時候〉所說:

> 對音樂的知識和對繪畫技巧的認識,這二者成為我發展文學的踏腳石,它們永遠賦給我在文學的世界裡有美感的質素,永遠具有聲音的格律和動人的形姿,產生我個人的真正風格。

是以晚年七等生的繪畫,或許提醒了讀者,重新把「作家七等生」(包含圍繞著他的寫作而起的種種爭鋒)置入「藝術家七等生」中。因為那裡存在著語言理解的起點,藝術家的內心之密,一扇永遠開啟,也難以抵達的美之窗景。從文學而至繪畫,如一種回歸,特別是,晚年獨居的七等生罹癌,念茲在茲的,仍是對生命更深的管窺。

## 在靈思的幻起幻滅中

和早、中期的人物與風景寫生畫不同,晚年七等生畫作,率多是隨興、隨筆的素描。七等生曾以書信說道不以文字,而以畫表達之意:「因為文字的約束和據緊,無法寬鬆延展的意涵,這也是我最近連續兩次用繪畫呈現的理由。」(2013.12.12)似可看出,完熟歷練文字戰役後,七等生猶有不足,仍渴望一種更自由,更具生命力的表達,書信道:

> 有一段時間了,記不得是那位學者的文評上說到七等生的作品的靈思常常是「幻起幻滅」。最近在省思之中,自己的生活瑣細亦然。時序輪迴,近日又臨「立春」;我一直在想,這段時日的氣

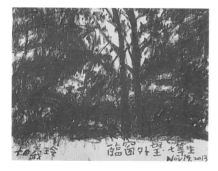

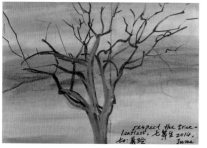

七等生畫作多以樹洩內心秘密

候怎麼是這樣呢？……馬勒交響曲聽者很難搞懂，原因是他的靈思也是幻起幻滅，尤其是滑稽搞笑的葬禮進行曲，九大交響曲中半數以上都有這個形式的樂章，其他依我的聽覺，大都是他散步時聽到的自然界的迴響和他童年的記憶陳述樂句，交融而幻起幻滅，每一次聽都感覺是第一次經驗……（2014.2.2）

我想對晚年七等生而言，繪畫是較文字更純粹且直觀的藝術內質，用以捕捉宇宙自然間，幻起幻滅的心之印象、美之一瞬。然或許罹病之故，七等生的畫筆所之，多在步履所及的觀看之地，從遠眺世新大學，到居家附近景觀，值得注意的，樹，始終是七等生感應幻起幻滅的核心。一次七等生寄來畫作，又補寄信件說明：

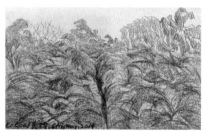

> Good 義玲，不得不再補上這封信，想告訴你的是「臨窗望外」的那株樹幹已經消失了，窗外繁華也淨空了，臨窗只有一大片灰白，遠處的樹梢在風中搖曳。那是前天的事……對於景物的記憶總是要及時行動，否則空口無憑徒嘆而已。（2014.3.28）

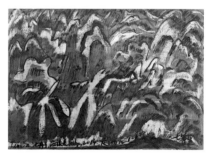

淨空的窗外繁華，七等生目睹了一場樹之死亡，幸有繪畫，否則無以證明他曾與森森翁鬱的生命交會。然而觀窺未完，一個月後，七等生再補記：

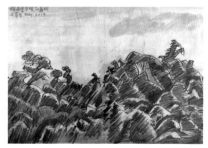

七等生的樹畫，帶著強烈感覺，在光的運動性中

> 前信未詳述那鋸斷的樹。我很痛惜它們，是午休時躺臥轉歌即能見到的窗外景物，是長時而逐漸感觸而來的。我的畫留有原貌的外形，然而卻是我的心布局和著色，有如古老警諺所說：要看到看不見的是經由看得見的。也是 good girl Anna 認同的：The art was true，the key to life。美感經驗。如今，樹已經不存在於現實，……多年的感觸，文字已經繁是瑣……沒想到此舉好似洩漏了我和樹之間的祕密，過了幾天，路過時高望即見到枝葉轉灰乾枯……我只是傷心痛哭。（2014.4.30）

是因為「多年的感觸，文字已經繁瑣」，所以捨文學而取繪畫。以畫以樹，七等生渴望從現象世界轉入感覺世界，再轉入生死之際的生命自體世界——因為樹死了，昨日的欣欣向榮，已成今日觀看的虛空。生死幻滅，人與樹俱在宇宙自然中，是以人要哭泣，人要尋求，人要盼望。樹的啟示，

感覺在色彩的運動中流轉，以樹以畫，那文學世界的亞茲別，離城以後要往哪裡去？晚年七等生以畫給出了答案。

## 坐下來休息

便是如此，樹，畫樹，構造了我對晚年七等生的理解，因為那裡有生死俱在的歡悅與陰影，隱藏著再度進入七等生文學世界的線索，以一種不休止的生命追求。七等生畫樹，窗邊的樹與山裡的樹，路邊的樹與夢中的樹，以樹來道出文學未盡的言說，因為生死之際，情思的幻起幻滅，人既哭泣也尋求安慰，而樹，也提供庇護。一次我提到父親癌末不適，七等生來信鼓勵，溫暖問候，並提醒不要干預老人，不論行動或思想。信末附詩「坐下來休息」：

晌午前，樹蔭下／猶有些許涼氣／河堤對岸的重重山嶺／眾樹如若獸群／列隊成伍／綠意盎然／望風搖舞／而百里外遙遠的山藍／淡薄一片／偏向南方／頂上灰濛浮動的雲霧／遽然鬆開一處／傾瀉聖庭的光束／與近前的陳雜景物／形成奇幻的寰宇帷幕

然而多少人從這堤道行過／寬闊的溪地草場和設施／提供大眾來遊戲和運動／而我算是一個灰髮年邁的遊人／心田裡埋著欲歸故里的諸種緣由／但在這午晴的梅雨季／受誘於翠綠山林的嫵媚召喚／素描的本能由衷產生形構他們的葉理和縫隙／且住 ——……／唉，我告誡著自己：／何時何日能再振奮體力／途經這張飽受風霜的木凳／坐下來休息……（2014.5）

這是被凸顯為孤傲性格的七等生另一面：感傷且軟弱。但是老矣老矣，生命需得神啟般的山嶺眾樹來仰望。於是生死幻滅的樹之意象裡，我所知道的晚年七等生，正是以光影俱在的行旅，踩踏在深邃的時間之境中。

2019 後，握不住畫筆的虛弱，七等生將樹從白色紙頁移至心中，以不同畫式畫樹，那樹影搖曳的色彩、線條與構圖，被身體的虛弱轉換為更純粹且幽微的音聲訴說，以馬勒交響樂的聆聽，渴望將青春的虛空譜寫為生命的哀／愛歌。

〈坐下來休息〉原作

2020 年 10 月 24 日，七等生再往樹影一步，終於全身翳入林蔭。彼時，遠方天際仍有光，他以輕盈自由的形體，真正坐下來休息了。或如〈我年輕的時候〉，七等生自己預言了那一刻：

**我依然寂寞和孤獨，可是人生我已活過，責任我已盡過，我就不會像年輕時那樣徬徨憂慮，焦躁而恐懼。晚間是我的安息。當第二天的凌晨再來臨時，我的靈魂已經投入於另一個嬰孩的誕生，因為我的肉體生命也是原本為了寄存一個原先的靈魂而產生。那新誕生的嬰孩依然會醞釀成長，依然有他的年輕時代，依然有他的工作。但那是另一個時光的天地，就與我這個肉體不再有關係了。**

是這樣的自我預言，2021 年，自紀錄片上映、七等生全集重新出版，至作家紀念專輯、畫冊的推出，樹的天光搖曳中，七等生的一個個新嬰孩隨之誕生。

原載於《文訊》2021 年 3 月號

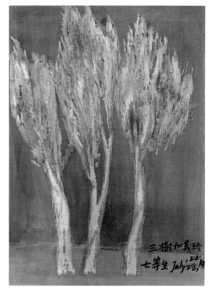

《三樹》，七等生意圖呈現美麗

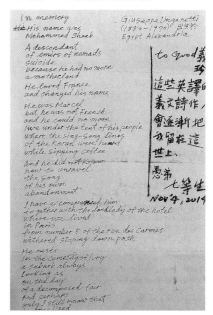

2019 年七等生所愛的詩作，曾不斷提起

# 在無盡的山色海景間，詩意地棲居

張禮豪

寫作暫時停頓了，卻想到要繪畫，譬如今天我到海濱散步，坐在沙灘的救生船上望著海洋湧來的潮水，和沙灘上插著的竹籬，就想繪一張簡單的水彩畫。

—— 七等生《譚郎的書信》

第一次接觸到七等生的繪畫創作，大概是台灣商務印書館《思慕微微》一書的封面。不清楚是全圖抑或局部的畫面中，描繪了一名身穿李子色運動外套與橄欖綠長褲的男子，雙手向後支撐坐在突出於大片草地的石頭上的模樣。而在映襯著湛藍的海水與一片帶著低垂白雲的天空，又是背光的情況下，以暗紅抹去面容細節的男子顯得更為陰鬱，說不出是其自況，還是針對某一特定對象的寫照，遂一方面消弭了主體與客體之間的差異，另一方面彷彿形成一個連結天地之間的甬道，吸納了無盡綿長的情感與意念……

後來才知道，本名劉武雄的七等生，自幼就會收集紙條，在上頭描繪人物故事讓鄰里大小觀看；後來更是秉持此一興趣，而從台北師範學院（今國

立台北教育大學）藝術本科畢業。也是如此，在其長達數十年的文字創作當中，讀者經常可以看到與藝術相關的活動紀錄。他曾經寫到先去阿波羅畫廊，再到春之藝廊看洪瑞麟畫展的段落；另外跟友人的往來信件當中，也不乏他對於藝術的觀點及看法。像是在 1984 年 4 月 21 日寫給藝術家楊熾宏的信中，七等生極為讚許其創作，並且這樣寫道：「……你那能響出交響樂樂音的繪畫是世界繪畫史上的一個新員。現在已經看到你的起步，我為你感到喜悅和驕傲。另一個同樣使我敬重的是謝德慶。……」凡此種種，都表露出他對於現代藝術發展不囿於一格的濃厚興趣與開放胸懷。

## 山色海景為題，堅信藝術價值

回到七等生的藝術歷程，《重回沙河：1981 年生活札記。攝影》一書可說是一個重要的見證。他自言：「我想我為自己設想的拍攝工作，是既辛苦又微不足道的，我相信往後會越來越艱辛。……據我的覽閱所知，世界上在拍攝表現優異的人非常多，在台灣的文藝圈裡也有幾位我敬仰的攝影工作者，他們起步很早，頗有心得和建樹，我在這樣的瞭解下是自嘆不如他人的，可是我並不恐懼，我知道我的工作完全是為自己而設的，我能繼續不斷地拍攝下去就是了，其他的顧忌都是多餘的。」

我們大致可以斷言，攝影對七等生而言，純然是一己生命片段的紀錄。因此，在幾乎清一色都採橫幅構圖的黑白影像中，不乏偶爾失焦、曝光過度或由於底片漏光，導致畫面不盡完整，甚至刻意實驗暗房技巧的作品；而無論是拾荒的老人、走向沙河的學童，或者快速運行的火車上透過窗戶所拍攝的晃動鄉村景致，乃至於夜間站在路旁、透過長時間曝光任往來車燈軌跡劃過身上，形成帶有幾分幽魅的自拍照等等，都可以清楚看出他不在乎攝影的機械性規範，也無所謂題材的喜好與限制。而多張以樹木、沙洲或晴日白雲為主的遠景照片，不但是召喚其生命經驗的關鍵物件，也理所當然地成為他日後部分繪畫的憑藉及參照。

按照目前的資料，一般都提及他從 1989 年起重拾畫筆，把重心轉向繪畫，並曾先後在欣賞家藝術中心、東之畫廊舉辦過兩次個展。由此或可窺見，邁入晚年的七等生，事實上不過是回返到他原本就已熟悉的創作媒材，藉以更為深刻地體現出個人的生命經驗與精神特質。而在此次「七等生：天

與地的現象」一展中，除了前述以刻意抹除面容的人物入畫之作以及僅見的一件自畫像之外，餘下近 25 件繪畫大多以植物、山色與海景為題，既可以見到泰納（William Turner）富於浪漫的蠻荒景致，也有塞尚（Paul Cézanne）尋求色彩與形體之間的和諧，進而賦予繪畫更多元的思考以及美學辯證關係。

其中，幾件盆栽的速寫作品，不難看出他養成多年的寫生習慣以及有意識地描繪單純形象的企圖；其所欲追求的顯然不是盲目地「再現」的傳統，而是將之視為自身在場的重要見證，一如他慣常使用的書信與日記體例的文字書寫，在充滿生活感的絮絮叨叨中逐步開展為內在自我的庇護所。

而展出的油畫大致可分為兩類，一是延續植物或盆栽速寫而得，選用的色彩上不算豐富，但透過了兼具穿透與阻隔功能的構圖與細微的色階變化，讓空間產生介於室內空間與戶外自然的模糊狀態，以此建構出個人情感與記憶棲居的詩性場域，同時加諸觸媒般的功能，使觀者也能跳脫日常的視覺經驗。另一類則是將視線拋擲到相對較遠的海邊沙洲或山色林間，以看似相對開闊，卻不見起點，也不知止於何處的場景描繪，偶爾還在畫面點綴時間感強烈的物件，像是擱淺在黃沙上只留骨架的船骸，或者豔陽照射之下而顯得亮晃晃的礁石等，都在迂迴的視覺敘事中植入詩性的象徵，而營造出更多值得推敲想像的空間。

舉例來說，雲的聚散是日常生活中人們慣見，卻也經常忽略的自然現象，處於具象與抽象間的特質也被藝術創作拿來當作特殊修辭。而在與此次展題同名的《天與地的現象》一作中，七等生即以遠方橫伸而出的堤防為刀，把畫面一分為二，接近蛋形的水藍雲朵佔據上半部的中心，與下半部筆觸鮮活、色調濃郁的大片土坡形成強烈的對照。在看似風景畫的外在樣貌下，暗藏了他不願固著於一處的性格表現。

《葉下交談》一作以極為獨特的視角，描繪在這，怒張如傘的偌大葉子在灰色陰影的交錯下，猶如形成了一個帶有強烈私密性的半公開場域，於葉際間投下了正在竊竊私語的兩張變形身影，帶出強烈的閱讀想像。其他如《雜樹、蔓藤和荒草的啟示》、《是迎迓或威嚇》等作，畫面中不約而同地在迅疾旋繞的筆觸與色彩堆疊交錯下，像是描繪了一個看似未經修飾的

不名之地，無須去試圖辨明地景之所在，只因它實則指向了我們置身人世一隅（coin du monde）的落腳之處。

不難看出，七等生和與他年紀相仿的英國藝術家大衛·霍克尼（David Hockney）一樣，都堅信繪畫不會消失，因為它無可取代；甚至包括攝影等其他媒材的創作底蘊，都應建立在繪畫之上。如果說，七等生的文學觀如其所言，是為了在他所處的那個污濁混亂的世界「使我們更了解人類歷史和世界環境，更真確的使我們窺見內在世界，淨化和安慰一顆不安的心。」那麼他的藝術創作無疑是更為內斂直接的情感寄託。站在這些作品前面，彷彿他仍一直詩意地棲居於無盡的山色海景與林間葉下，引領著我們走向各自記憶的深處，甚至記憶之外的廣袤宇宙，並向這個時代持續探看。

# Belated Appreciation for Chi Ten-Shung

Xi Mu-Rong

1. Let us look up at the stars, gazing at their miniature yet intense radiance. We are not the last of human beings.

- Chi Ten-Shung , *Safeguard*

Huai-Zhuo called and asked me to write a few words about the paintings left by his father. Over the phone, I couldn't help telling him about my sense of surprise when I first met Chi Ten-Shung: How could there be such a happy and open-minded person!

It was probably the second semester of my first year at the Taipei Normal School Department of Art. In the large student cafeteria, lunch time was nearly over when laughter was heard from one side of the hall. As the excitement grew, everyone began looking over at where the sound of laughter and applauds came from. It was an older male student standing on top of the long wooden dining table. He stood upright at the table center with both arms held high while swirling around in a dance. The dance steps looked a little like what we knew as Spanish folk dance. The dancer who appeared thin and flexible moved with abandon and joy…

After that, my memory became blurred. Did the school official blow the warning whistle or come straight over to shout at the dancer? Anyway, the detail of the drama was fully revealed only after the summer was over. In the beginning of the next semester, it became known that the dancer's classmates were protesting the poor quality of school lunch, and someone cleared the dining table. Just then, the dancer leaped onto the table and began a solo performance, in clear violation of school regulations.

Yet, how could it be that his punishment was to repeat the school year, and thus joining our class?

Huai-Zhuo finally resolved the mystery for me. It was his aunt, Chi Ten-Shung's older sister, who begged some friend to appeal to some official from the Department of Education or some institution to intervene on the matter. Thus, Chi's original punishment of "expulsion from school" was changed to simply "repeating a grade".

As a result, Chi and I became classmates.

However, young as we were in an era when most people were a little suspicious and guarded against each other, everyone seemed to be divided into opposing teams of black or white. Looking back at the time, even the pastors who stood on the podium were simply following orders. They were the same as their flock of sheep, trapped in a place fenced in by thorns.

As a result, young as we were in the same classroom, it was difficult to become acquainted, let alone understand each other. Among the students, how many had longed for starlight to come and guide our souls?

One time, I remember this classmate, who came and went by himself, passed by on the long corridor when the sunbeams came in a little sideways. With his light-color and seemingly translucent eyes, he hastily glanced at those of us in the classroom with a warm look of compassion.

> 2.  Step by step, my writing reveals the dark side of the world within my heart, again and again washing and clearing away my inner accumulation of sludge. My words have two layers of meanings: calmly demonstrating and analyzing various existing phenomena, while also showing my caring and sympathy.
> - Chi Ten-Shung, *When I Was Young*

In November of 1992, in an art book published by the Appreciators Art Center, Chi Ten-Shung wrote in the preface:"I've loved music and painting since childhood, and unexpectedly stepped onto the path of literary writing after graduating from school and began working. Drifting and wandering over the past 30 years, I sought only to keep myself and family warm and fed. After retirement, I reconnected with the joy of my childhood, holding the paintbrush with trembles just to whittle away the time in my old age.

These words seem to divulge a type of "concession". However, in this artbook, in contrast to his literary writing, most of the paintings by Chi Ten-Shung are full of warmth and saturated colors. The art revealed how the artist was moved by spiritual unification with nature, which was a type of spontaneous emotion originating from within life itself.

I believe that Chi Ten-Shung chose the subject of his paintings at that time. Wielding a brush to apply heavy brushstrokes and dense colorants, he painted with abandon without any restraints. Such vigorous vitality and strong desire to speak out is the joy of childhood re-established after life's trials and tribulations – it is probably the most precious part of the paintings at this stage.

Huai-Zhuo didn't give me too much material for reference. The paintings in this old art book, of course, were all works completed before 1992. When we were middle-aged, Chi Ten-Shung and I had happily reconnected through literary exchanges. After my first book *Painting Poetry* was published by Crown Publishing Co., Chi encouraged me by writing a long review of roughly 10,000 words published in the supplement of the United Daily News. However, after his retirement, I never got a chance to see him again. Therefore, I have no clues regarding his paintings later in life, and feel uneasy because I don't know where to start my writing.

Thankfully, in this year's March issue of *Wenhsun* Magazine, I read the article about the

correspondence between Prof. Xiao Yi-Ling and Chi Ten-Shung in his later years, and the letters and paintings sent by the artist. The information gave me important clues. It turns out that the type of explosive brushworks in oil paintings completed in the early period of Chi's retirement had gradually quieted down. Therefore, the few single-color tree sketches completed from 2013 to 2014 by Chi displayed a type of calm and unhurried brushstrokes, even though the dimensions of the pictures were small. A type of faint and vague musical rhythm was displayed magically, almost equivalent to the poetic background that emerged hazily from time to time in his literary works.

Thanks to Prof. Xiao Yi-Ling, who provided these pictures done by Chi Ten-Shung in his later years, we get to understand that there is more than one source to the creative talents innate in each individual. Chi had spoken of his regrets about abandoning childhood favorites of music and painting during his three decades of literary creations. In reality, hidden in numerous corners of his literature are the nourishment offered by music and painting, which stuck to him like shadows and never abandoned him.

Yes, this is a type of "imperceptible comfort and guidance" like aprovision of nourishment that is delicately subtle without much fanfare. Thankfully, thankfully the artist left traces for us to believe and feel the possibility of being "nourished".

3. Truly excellent works are no more meaningful than making the author's heartbeat noticeable. If the texts contain some amazing significance, it will eventually decay and be eliminated over time. What is truly inspirational is the heartbeat …
   - Chi Ten-Shung, *Literature and Literary Criticism*

Huai-Zhuo sent over a set of Chi Ten-Shung's "literary cards", which were black-and-white landscape pictures taken by the author plus excerpts from his books. I selected three of the passages as follows.

Originally, I thought the cards were selected by Chi Ten-Shung. I even said to Huai-Zhuo that the passages chosen by the author are usually the core of his beliefs. Unexpectedly, Huai-Zhuo answered:"These are the cards I designed for my father late in his life. The photographs and text were also selected by me over time."

At this end of the telephone, my heart was filled with waves of warmth in an instant. Yes, there is nothing more important.

If after a long, long life, a creator who desired freedom without restraints and despised being categorized could receive the gift of forgiveness or even an in-depth understanding from his children, then there is probably nothing more rewarding or meaningful for a father.

# From the Original Intention of Rebellious Self-Awareness To an Artistic Enlightenment

Liu Huai-Zhuo

In our memories of youth, there was no shortage of moments when we wished to cast ourselves excitedly towards this expansive world, to sacrifice and show off our full emotion or whimsy of the moment. This sacred moment may be no less than the wonder of our first confession of love. Unfortunately, this is usually the starting point of broken wings or a long journey for the young, especially those leaning towards a path of creativity as they gradually begin to understand the balance between the mainstream reality and power. Initially, Chi Ten-Shung first came to fame in 1962 after several of his short pieces submitted for publication demonstrated his unique literary style. However, the publication of Chi's controversial novel, *I Love Black Eyeballs*, encountered harsh criticism by the mainstream academia. He was even spit at by some literary figure during an argument, but Chi Ten-Shung just let the spittle flow down his face without saying a word.

The creative expressions resulting from Chi's instinctive sensitivity and acuity was not tolerated in the closed-minded cultural ideology of the time. His audacious breakthrough thinking was only looked upon as rebellious heresy harmful to society. Compared to the art community that always encouraged innovative symbols and unique banners, Chi Ten-Shung probably never dreamed of the rigidity upheld by the literary circle of that time. Originally a student at the art department of Taipei Normal College, Chi longed for an art world with room for freedom of expression and imagination. His interpretation of the modernist style is already visible in his experimental painting completed at his residence in 1968, *Sketch of the Cloth Horse* (displayed at the exhibition), a minimalist imagery with free-flowing color blocks and outlines. Even though his nature would have preferred artistic developments, he was left with little choice after getting married and having to raise a family. Thus, he returned home to teach for a living. However, his sense of rebellion that was repelled by the outside world had already triggered the self-awareness of artistic spirit. Using words, he continued to go against all of the social environment that regarded him as heresy or having the lowest status. He used his writing to prove his ideal literary format could be unlimited to some purpose while achieving in-depth comfort and inspiration of humanity.

First of all, the purpose of writing is to preserve my own memory while keeping a record of the world, in an attempt to separate the me that became mixed up with the world. Therefore, a pseudonym for me is a time when I must defend against

everything in life, especially in my living environment where they are nearly collectively leaning towards some bogus value.

– Chi Ten-Shung, *Five Years Collection* Epilogue

In 1997, Chi Ten-Shung's first complete set of ten novels was published. Under the age of 40, Chi seemed to have accomplished the maximum expected of a pure literary writer at an amazing speed. Why did he have such an explosive writing capacity?

Only he himself could explain. He seemed to be stifled by all the pretentious phenomenon in the surrounding society of that time, and had to find an outlet to express the real world that represented another facet of his heart. It was only possible to accomplish in his novels. Most of the formats of his novels were not realistic stories. Instead, he created tart characters similar to those in allegories, as well as frictions, conflicts or sufferings of the real world. The ambiguity of time and space made it seem like a scenario within a dream, though the derived emotions of readers are real. His novella *Mentally Ill Patients* was just like the nightmarish oppression in Kafka's novels. With his numerous dreams or fantasies, Chi Ten-Shung established an even higher value of truth recognized by his heart. His novel *A Lean Soul* (originally named *Bad Child*) records a time of teenage madness of the protagonist Wu-Hsiung, especially his experience in the suffocating system at the teacher's college. At this time, the 40-year-old Chi Ten-Shung was able to review his rebellious shadows of the past using artistic techniques. He wrote about the protagonist's love for painting and music without reservation, just like a genius who has been captured by art but remains ignorant of art. Later, in his prose *When I was Young*, he also spoke of his knowledge about music and painting skills. Both art forms became the stepping stones for his literary development, forever granting him a sense of aesthetics in the literary world, forever equipped with the rhythm of sound and moving postures that produced his true individual style. This is an important factor propelling him to become a literary master.

Literary critics have always enjoyed discussing the emotional atmosphere and illusionary surroundings that Chi Ten-Shung was good at creating in his novels. Intuitively, perhaps such a style can be compared to the Impressionism or Expressionism, which features even more radical emotional effects. Chi never forgot about image creativity. He stopped writing temporarily to set up a darkroom studio in 1980, and began to present the reality in his eyes via photography.

Therefore, *A Return to Sand River* published in 1985 featured a series of black and white original photographs that surpassed the documentary photography of the time. The images revealed that the vision he set out to capture would contain even more metaphors, but he had far to go before reaching his ideals and made few attempts afterwards. During this period, the major significance was his process of organization and precipitation of artistic contemplation, from the presentation techniques and formats to his metaphysical ideology. Again and again, he observed and refined himself based on the reality of life, formulating a vision of appreciation comparable to Lao Zhuang's philosophy and Croce's aesthetics. After heading to the U.S. in 1983 to participate in an international writers' workshop, Chi's literature began to draw the attention of foreign scholars, who published theses or translated editions of his writing in the U.S., France and Italy. In Taiwan, however, it was as late as 1990 when Prof. Liao Shu-Fang (a graduate student at the time) wrote the first master's dissertation on Chi Ten-Shung, which was 28 years after Chi's writing was first published. Nevertheless, after the publication of *A Return to Sand River*, Chi Ten-Shung already understood that the pursuit of art was

only a record of human's roundabout movement towards the 'Path' in their attempts to approach the truth. Thus, he no longer cared about slanders or praises from the outside world. After the publication of *Letters of Young Mr. Tan*, his urgent desire to write ceased. Through the format of letters in the book, he poured out his wish of only serving as an artist who is completely devoted to good and beauty. His own analysis of his inner hidden vibrating thoughts is akin to a demonstration of how far human beings may reach deep within their souls.

> ... Just remember that there is this type of human being in the world. It does exist. Beyond all the human exterior behavior and appearance, inwardly there is this type of soul.
>
> - Chi Ten-Shung, *Letters of Young Mr. Tan*

In 1989, after retiring from his teaching post, Chi Ten-Shung was finally able to unload the burden of livelihood. Not a moment too soon did he embrace his original love of painting. Once a wild and rebellious youth, he had weathered through the trials and tribulations of reality in life. He understood that poetry was the textual truth of art, and painting was the "portrait of ideals" capable of integrating with his own consciousness to form the same emotional pulsation. Thus, in the 61 paintings (included in the artbook) selected from his nearly 100 paintings, we can feel similar objects and rhythmic sensations described in his poetry.

> Suddenly my spirit calls
> Asking me to walk toward a swan
> The autumn sun shines like a fire wheel
> The lonely and remote gray trail
> ... ... ... ... ... ... ... ... ...
> Quietly, I entered the forest of whistling pine trees
> Just a little tranquility is my Holy Land
> Standing atop the soft sand dune, I focused on
> That sound formed in between the birth of white waves and disillusionment

In the early period of Chi Ten-Shung's writing career, one literary master had claimed Chi to be a literary apostle. However, he never got to see that Chi Ten-Shung would go much further on the path of art, possessing the spirit of an artist from the beginning to the end. Thus the description of an 'artistic apostle' is perhaps more suited for Chi. Rebels are summoned by the times, prompting them to knock open a window of light in the suffocating despicable reality of human spirituality. Chi Ten-Shung may have started with rebellion, but the path he was on was the artistic path in search of the truth. He once said that nature is impossible to imitate, and that sketching by copying is wasted effort. The continuous re-discovery of themselves every time people approach nature is of the greatest value. He embodied this concept of idea sketches in his paintings, where the mountains, seas, trees and forests were all transformations and integrations of the space/time reality with himself, already becoming an even more realistic spiritual phenomenon.

Using the dual art forms of literature and painting, Chi Ten-Shung had a complete record of his life-long exploration process of the inner essence of human nature. I call it "the path to enlightenment" instead of "enlightenment", because he said in his last appearance in a documentary: **I am alive, that is the truth ... I am still trying every day to understand a little more, exactly what am I?** Of

course, truth does not consistently exist in the same format. Similar to the Ukiyo-e master Hokusai's feeling prior to his death regarding profound unfinished works, Chi Ten-Shung devoted his life to a higher existence, and transformed into a more in-depth and comprehensive artistic incarnation. As an encouragement for people of all generations making the same attempts at creativity or are already on this path, I present this passage Chi Ten-Shung gifted to his classmate and good friend Xi Murong:

"There is only one way to the heart's desire in life. The right path of creativity is sincerity, and the good intention to avoid sidetracks."

Wu-Hsiung
22 October 1980 in Tungshiau

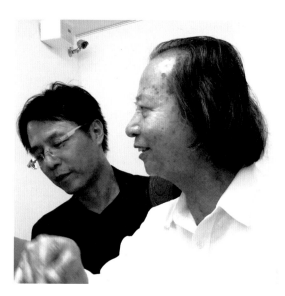

Chi Ten-Shung and Liu Huai-Zhuo

Xiao Yi-Ling

> I excel at making selections of what I need… My paintings may look like arbitrary creations, but in fact, a countless number of existing images can be found, intentionally or serendipitously.
>
> - Chi Ten-Shung letter, 30 July 2014

Looking at Chi Ten-Shung's writing journey, the literary community in Taiwan never again received any information on his writing after the publication of *A Little Yearning* (1997), winning of the National Award for Arts in 2010, and the publication of *Why Persevere? – Selected Works of Chi Ten-Shung's Novels*. The retreat of such a mysterious novelist with a strong personality, however, has aroused even more curiosity. What was he up to in his old age?

## He was still writing

I first met Chi Ten-Shung in 2012 during a press conference for the release of *Why Persevere? – Selected Works of Chi Ten-Shung's Novels*. In the following eight years prior to his death in 2020, Chi often wrote to me about his life, memory, and his views on art. To sort out all the inextricable details, I think that perhaps we can start with that point in time when he announced publicly that he would stop writing after the publication of his complete works. I asked: Why do you write no more? He answered this way:

> It was 10 years ago when I stopped writing. I will pick up my pen and write again, but not in the format of a novel. ( 22 January 2013)

Later on, I mentioned again that I hoped to see his "textual" writing, and Chi Ten-Shung replied this way:

> The paintings I completed the few years after my retirement are just like my textual works, filled with my personal memory of this world. In my understanding, what Anna (Mahler's daughter) said, "the universe makes sense", means exactly that. (15 November 2013)

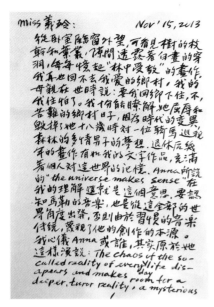

Letter from Chi on 15 November 2013

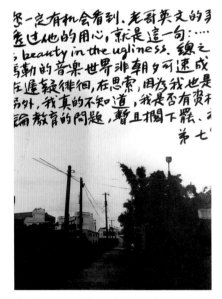

The photo as a gift from Ah-Fen to Chi

At the end of the letter, he attached a picture sent to him by Thomas A. Metzger, a scholar of Chinese history in the U.S. The picture had been taken by Metzger's wife Ah-Fen when she had returned to her native country in Taiwan. Chi Ten-Shung liked the picture because of "the arrogance of the backlit tree, the muted greenery and the gray road leading to who knows where." Finally, he wrote, " ... but there is beauty in the ugliness." Ugliness vs. beauty and darkness vs. light - yes, living right here. If I were asked what was Chi Ten-Shung up to in his old age? I would answer: The Chi Ten-Shung that I know was still active in his own art, not through words but through painting. He was still writing, purer writing that was more intuitive.

### "The world looks calm and beautiful on the surface, but my heart is restless."

Perhaps we've focused too much on Chi Ten-Shung's literary writing and overlooked his paintings. Looking back, Chi had been preparing to concentrate on paintings even before his retirement. In 1994, he opened an art gallery and held exhibitions. Even though it was for a short time, an overview of his life would reveal that painting may be the expression that was succinct and closer to the core to his artistic world. Or perhaps painting was in the midst of his writing, a side of him that was interdependent with his literature. Looking even further back in time, as early as in his prose *When I was Young*, Chi Ten-Shung had spoken about the importance of painting to him. He also talked of his artistic inspiration: When he was young (23 years old), he was "very isolated and lonely" while working as a teacher at the Jiufen Elementary School in the mining area. The reason being: "The world looks calm and beautiful on the surface, but my heart is restless." One day while passing by the miner's resting place, Chi's attention was caught by a short and overweight miner lying on a long bench, who was piercing through the tube made by his fingers and through the gaps between the leaves above his head, all the while speaking his heart. (It was Hung Jui-Ling, the miner painter). Such a look of contentment in a lonely place moved Chi Ten-Shung. After another period of sheltered experience, the young Chi Ten-Shung found himself with another pair of eyes, such that he could see his own movement in time. Even more surprising was that he could speak another language that differed from others. Thus he wrote: "*Half a year after he completed military service, Toshi came to my house at 8 o'clock in the evening when I was playing poker on the small square wooden table under the light with a musician.*" (from *Unemployment, Poker, Fried Calamari*) Thus, novelist Chi Ten-Shung was born.

Painting and the Hung Jui-Lin incident gave us a new focus of understanding regarding Chi Ten-Shung's literature and language, perhaps an even more creative discernment. From Hung Jui-Lin to Chi Ten-Shung, it is evident that the language of artists is not in the expression of reality, but in a true harmonious existence with the natural universe and a real sense of the self. The literary language of Chi Ten-Shung originated from a special type of self-examination and observation. Painting was an even more direct expression of vision, as in *When I was Young*:

> My knowledge of music and understanding of painting skills became the stepping stones on the path to develop literary writing. They imbued a sense of beauty for me in the world of literature, always embodying the rhythm of sound and moving postures, which produced my true personal style.

Therefore, the paintings of Chi Ten-Shung in his later years perhaps reminded the readers to

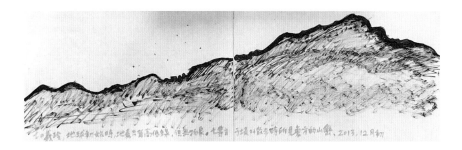

"At the beginning of earth, there were only high and low lines on the surface but no existence of objects." It was exactly the characteristics of the aesthetic quality of Chi Ten-Shung, which emphasized the spiritual flow.

reposition "writer Chi Ten-Shung" (including all of the controversies surrounding his works) as "artist Chi Ten-Shung". That was the starting place of language comprehension, the artist's inner secret, as well as a beautiful scenery outside the window that was always open but impossible to arrive at. The journey from literature to painting was like returning to one's roots. Especially, when Chi Ten-Shung was living alone in old age and suffering from cancer, his mind was still occupied by the desire to conduct an in-depth exploration of life.

## Within the illusion and disillusion of spiritual contemplation

Many of Chi Ten-Shung's paintings rely on trees to allude to his inner secrets

Different from the portraits and landscape sketches of the early and mid-period, Chi Ten-Shung's later paintings were mostly sketches casually drawn. He once wrote in a letter about the meaning behind expressions via painting instead of words: *"Because the restraints and tightness of words cannot allow relaxation or extension of meanings. This is also the reason I have used painting as the presentation method twice in a row recently."* (12 December 2013) It seems evident that after experiencing a complete battle with words, Chi Ten-Shung was not yet satisfied, and still yearned for another freer and more vital expression. His letter stated:

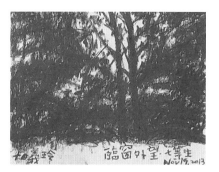

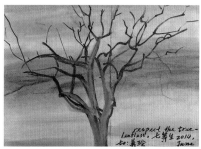

Many of Chi Ten-Shung's paintings rely on trees to allude to his inner secrets

> For a while now, I can't remember which scholar commented in an essay about the inspiration of Chi Ten-Shung's works is often "illusion and disillusion". Recently during a period of self-reflection, I realized my own life is also similarly trivial. As the seasons rotate, it is again the start of spring. I've been thinking, why is the weather like this in recent days?... Mahler's symphonies are difficult for the listeners to understand, because his spiritual contemplation is also illusionary and disillusionary, especially his comical funeral marches. More than half of the nine major symphonies have this form of movement. According to my auditory sense, the others were mostly the reverberations of the natural world heard during his walks and his childhood memory, which interweave and become illusionary and disillusionary. Every listening experience feels like the first experience... (2 February 2014)

I believe that in Chi Ten-Shung's old age, in comparison to words, painting was a purer and more intuitive artistic essence used to capture the illusionary and disillusionary impressions and instantaneous beauty in the natural universe. Perhaps because of his illness, Chi Ten-Shung's paintbrush often depicted places he could walk to, where he could see the Shih Hsin University from afar and visit sceneries near his home. Even more notable was that trees had always been the core of Chi's illusion and disillusion. One time, Chi Ten-Shung sent me some paintings, and followed up

with a letter with explanations:

> Good Yiling, I had to send this additional letter to tell you that the tree trunk in Looking Outside the Window has disappeared, and the vibrancy outside the window has been cleared. What is left is a large area of light gray, and the tree branches afar swaying in the wind. That happened the day before yesterday... Regarding the memory of scenery, actions must be taken immediately, otherwise it's just empty words. (28 March 2014)

Outside the clear window, Chi Ten-Shung witnessed the death of a tree. Fortunately, there were paintings. Otherwise, there was no proof of his lively encounter with lush greenery. However, the observation was incomplete, as Chi Ten-Shung sent another letter a month later:

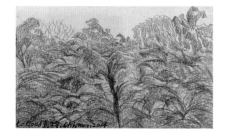

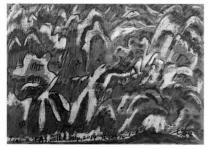

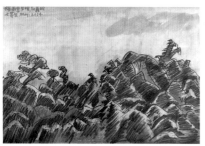

> My previous letter did not detail the trees that were sawn off. I felt very much for them, which were scenery outside the window. I had seen them during lunch breaks when I sat down or lied down. It was feelings that gradually developed over a long period of time. My paintings have preserved their original shape. However, it was my heart that performed the composition and coloring. Just like the old saying warned: The invisible can only be seen through the visible. Good girl Anna also agreed: the art was true, the key to life. It was an experience of aesthetics. Currently, however, the trees no longer exist in reality. With feelings of many years, words are already tedious... But this move seemed to have revealed the secrets between the tree and I. Passing by a few days later, looking up I saw the branches and leaves turning dry and gray... I just cried sadly. (30 April 2014)

Precisely because of *"the feelings of many years, words are already tedious"*, I gave up literature and chose painting. Based on paintings and trees, Chi Ten-Shung longed to transform from the world of the existing into the world of perception, before transforming into the world of life itself at the edge of life and death. Since the tree died, the lushness of yesterday became the emptiness observed today. Life, death, and disillusionment. Humans and trees are in the natural universe. Therefore, man would cry, seek, and hope. The revelation of trees is its circulation in the movement of colors. With trees and paintings, where is the literary world of Yazbe heading to after leaving town? The older Chi Ten-Shung painted to disclose his answers.

Chi Ten-Shung's paintings of trees have strong feelings, in the movement of light

### Sit down to rest

So the trees and the paintings of trees have established my understanding of the older Chi Ten-Shung. There are joys and shadows that exist in both life and death, with hidden clues to re-enter into the literary world of Chi in a persistent pursuit of life. Chi Ten-Shung painted trees - trees by the windows and trees in the mountains, trees by the roadside and trees in the dreams. He spoke of the unfinished words of literature with trees, because while on the verge of life and death, the emotional illusion and disillusion prompt people to cry and seek comfort. Trees also provide shelter. Once I mentioned that my father had terminal cancer and felt unwell, Chi Ten-Shung sent me words of encouragement and warm greetings. He also reminded me not to interfere with the elderly, whether in actions or thoughts. At the end of the letter, he attached the poem Sit Down to Rest.

Before noon, in the shade of trees
The air is still a little cold
Numerous mountains across the river
The group of trees like a herd of beasts
Lined up in a row
Full of Greenery
Gazing at the wind dancing and swaying

A hundred kilometers far away the mountain blue
A field of pale thinness
Leaning towards the south
Gray blurry cloud and fog float on top
Suddenly a gap opens
Light beams pour down from heaven
Against miscellaneous objects and scenery up front
Forming a fantasy curtain of the universe

Yet how many people pass by the causeway
Vast pastures and facilities by the creek
Provided for the public to play and exercise
I count as a gray-haired old traveler
Buried deep in the heart are various reasons to return home
But the sun came out abruptly in this rainy season
Lured by the enchanting call of the emerald green mountain
Sketching instincts engineered their foliation and gaps
Might as well stay put a little bit
Alas, I admonish myself
What time on what day can I reinvigorate my body
To pass by this weather-beaten wooden bench
Sit down and rest… (May, 2014)

This highlights the other side of the otherwise aloof Chi Ten-Shung: sentimental and feeble. However, when one gets old, life needs to look up at the grace of mountains and forests. Thus in the tree imagery of the life and death disillusion, in his old age the Chi Ten-Shung that I know was exactly a traveler between light and shadow, stepping into the profound realm of time.

After 2019, as he became too weak to hold the paintbrush, Chi Ten-Shung moved the tree to the center of the white paper and painted the tree in a different style. The colors, lines and composition of the swaying tree shadows transformed into a purer and faint voice due to weakness in the body. He listened to Mahler's symphony while yearning to take the emptiness of youth and compose a song of mourning/love of life. On 24 October, 2020, Chi Ten-Shung took another step further with his whole body into the shade of the tree. At that time, with light in the distant sky, he truly sat down to rest with a light and unrestrained form. Or just like *When I was Young*, Chi prophesied that moment:

I am still lonesome and alone, but I have already lived through my life, and fulfilled my responsibilities. Unlike my youth, I would not be worried, anxious and fearful.

the original manuscript of *Sit Down to Rest*

Night time is my rest. When the morning arrives on the next day, my soul has invested in the birth of another baby, because my physical body was also created originally to hold a soul. The newborn will still incubate and grow, live through his own youth and have his own work to do. However, that will be the world at another time, without any relationship to this physical body of mine.

It was this type of self-prophecy. In 2021, Chi's documentary was released and his complete works were republished, as well as a commemorative book and catalog. In the swaying light of the tree, one by one, new Chi Ten-Shung were born.

Originally published in the March 2021 issue of *Wenhsun* Magazine

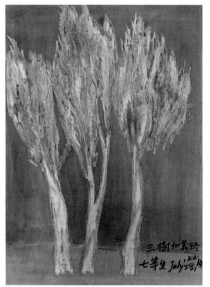

*Three Trees*, where Chi Ten-Shung intended to present beauty

A poem of Chi Ten-Shung that he loved and mentioned often

# Within Boundless Landscape, Live Poetically

Chang Li-Hao

Writing has been halted temporarily, but thoughts of painting began. For example, I went for a walk by the sea today and sat on a lifeboat on the beach. Gazing at the oncoming tidal waves and the bamboo fence stuck into the sand made me want to paint a simple watercolor.

- Chi Ten-Shung, *Letters of Young Mr. Tan*

The first time I came into contact with Chi Ten-Shung's paintings was probably the cover of *A Little Yearning* published by The Commercial Press, Ltd. It's not clear whether it was the full picture or a cropped image. The cover depicted a man dressed in a plum-colored sports jacket and olive-green trousers. He was sitting on a rock protruding from a large grass field with his body propped up by his hands in the back. In contrast to the azure blue ocean and low-hanging white clouds in the sky, the back-lit man appeared even more melancholy as his facial features were obscured by a dark red color. Whether it was a portrait of himself or another particular subject is impossible to tell. On the one hand, the difference between the subject and the object was eliminated. On the other hand, it seemed to form a corridor connecting heaven and earth, absorbing endless and lingering sentiments and thoughts.

Later on, I found that Chi Ten-Shung, whose real name is Liu Wu-hsiung, began collecting paper strips when he was little. He would draw characters with stories for neighbors to look at. He also followed his interest in school and graduated from the Taipei Normal College Department of Art (currently the National Taipei University of Education). That is also the reason that during his multi-decade literary career, readers often saw records of art-related activities. For example, he once wrote a passage about going to the Apollo Art Gallery before heading to the Spring Fine Arts to see Hung Jui-Lin's art exhibition. Moreover, in his correspondence with friends, he always wrote about his perspectives and ideas on art. For example, in a letter to Yang Chi-Hung on April 21, 1984, Chi Ten-Shung praised the artist for his works and wrote: "... *your painting that is capable of producing symphonic sounds is an innovation in the world history of paintings. Now that you've taken the first step, I feel so proud and happy for you. Another person that has my respect is Hsieh Teh-ching...* " Such words revealed his strong and unrestrained interests as well as an open mind toward the development of modern art.

## With landscape as the subject, believing firmly in the value of art

Returning to the artistic journey of Chi Ten-Shung, *A Return to Sand River* in 1981, serves as an important testimony. He said of himself: "I think the job of taking pictures that I envisioned for myself is difficult and trivial, and the level of difficulty will only increase in the future ... According to what I have read, many people in the world are very good at photography. There are also several photographers in Taiwan's art community that I admire. They got an early start and have already gained much experience and accomplishments. With this understanding, I lament that I am not as good as others. But I have no fear, knowing that my work was planned entirely for myself. As long as I can continue to shoot, all other considerations are unnecessary."

We can basically conclude that for Chi Ten-Shung, photography was merely a record of his life fragments. Therefore, in nearly all of the black and white images with landscape compositions, occasionally some images were out of focus, or overexposed, or incomplete negatives due to light leakage. Some images were deliberate experiments in the darkroom. Regardless of the subjects of the photographs, evidently, he cared not for the mechanical rules of photography. Furthermore, he had no so-called favorite subjects or limitations, which included scavenging seniors and school children walking towards the sand river. He also took shaky shots of countryside scenery taken through the window of a fast-moving train, and ghostly self-portraits on the roadside over a long exposure time, allowing the headlights of passing vehicles to create trajectories across his own body. Many of the images were photos of sceneries in the distance, such as trees, sandbanks, or sunny skies and white clouds – such were the key objects summoning his life experience, which naturally became the foundation and references for some of his paintings in the future.

Most of the references available currently state that Chi Ten-Shung picked up his paintbrush again in 1989 and turned his focus to painting. He had held two exhibitions at the Appreciators Art Center and the East Gallery. Thus it's evident that in his later years, Chi Ten-Shung simply returned to the creative media he was familiar with, allowing the emergence of an in-depth presentation of individual life experience and spiritual characteristics. In the current exhibition "*Chi Ten-Shung: The Phenomenon of Heaven and Earth*", in addition to a self-portrait and the previously-mentioned painting of a person with a deliberately blurry face, the remaining 25 paintings are mostly drawings of plants, mountain sand seascapes. Viewers are able to see both William Turner's style of romantic wilderness or Paul Cézanne's search for harmony between color and form, imbuing diversified contemplation and aesthetics dialectical relations to paintings.

Among the works, a few sketches of potted plants clearly show his long-standing habit of sketching, and his attempts at sketching simple images consciously. The purpose was to serve as an important testimony of his presence on-site instead of the tradition of "reproducing" images blindly. Just like his usual textual writing in letters and diaries, he was gradually developing a sanctuary for his inner self amidst the daily chatter in life.

Most of the oil paintings on display are one of two categories. One type is quick sketches intended to extend the life of botanicals or potted plants with the selection of not-so-rich colors. However, through subtle gradation of changing colors and compositions functioning as transparency and obstruction, the resulting space serves as a state of vagueness in between indoor space and outdoor nature. Such a space also became the basis to establish a poetic domain of personal emotion and the

habitat of memories while serving as a catalyst prompting viewers to escape from their daily visual experience. The other category is paintings with sightlines far away in distant sandbanks by the sea or in the mountains and forests, depicting a relatively wide-open space without a visible starting point or ending point. Occasionally, the picture may be decorated by objects with a strong temporal sense, such as the skeleton of a shipwreck stranded on the yellow-colored sand, or reefs looking radiantly under the sunny sky. The effect seems to be embedding poetic symbols in the indirect visual narrative, which creates more space deserving of examination and imagination.

For instance, the gathering and dispersion of clouds is a natural phenomenon that most people are accustomed to but regularly ignore. The quality of clouds in between the concrete and abstract is also used as a special expression by artists. For the painting with the same title as this exhibition, *The Phenomenon of Heaven and Earth*, Chi Ten-Shung used the horizontal dike in the distance as a knife to divide the picture in half. The egg-shaped blue cloud occupies the center of the upper half, forming a strong contrast with the colorful hillside painted with lively brushworks in the lower half. Hidden underneath the exterior of the landscape painting are the expressions of his characteristics that are unwilling to stay put in one place.

With a unique perspective, the work *Conversation Under the Leaves* depicts giant leaves like wide-opened umbrellas under interweaving gray shadows, seemingly delineating a semi-public area with a strong sense of privacy. Two whispering deformed shadows are cast in the gap between the leaves, eliciting strong imaginations from the readers. Other works such as *The Enlightenment of Sundry Trees, Spread Rattans and Waste Grass* and *Is it Welcome or Intimidation?* both seem to depict an unadorned and unknown place under the swiftly twirling brushworks interweaving with the stacking of colors. There is no need to make an attempt at discerning the exact location, only because it actually points to where we are setting foot in the world (coin du monde).

It's not difficult to see Chi Ten-Shung's similarity to David Hockney, the British artist who is about the same age. They both believe firmly that paintings will not disappear because they are irreplaceable. Perhaps various other creative media such as photography should be based on paintings. If his literary perspective was as he said, created for the dirty and chaotic world in which he existed, *"To enable us to better understand human history and the global environment, to enable us to get an accurate glimpse of our inner world, while purifying and consoling an uneasy heart"*, then his artistic creations were undoubtedly a more restrained and direct emotional sustenance. Standing in front of these works, he seems to continue to live poetically in the boundless landscape, in the forest underneath the leaves, guiding each of us to the depths of our own memories or even the infinite universe beyond our memories while exploring this era continually.

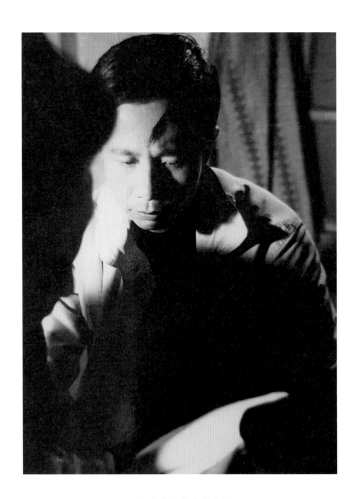

1960 年代七等生於台北
Chi Ten-Shung in Taipei, 1960's

當我們思想時，最大且最高的要先想。
但當我們要去實踐它時，最小且最低層的要先做。

——〈晨夢〉　《重回沙河》

When we think, we think the biggest and the highest first;

but when we execute it, we start with the smallest and the lowest.

— 〈Morning Dream〉　《A Return to Sand River》

風景 Landscape
1989
紙本粉彩 pastel on paper
38 x 52 cm

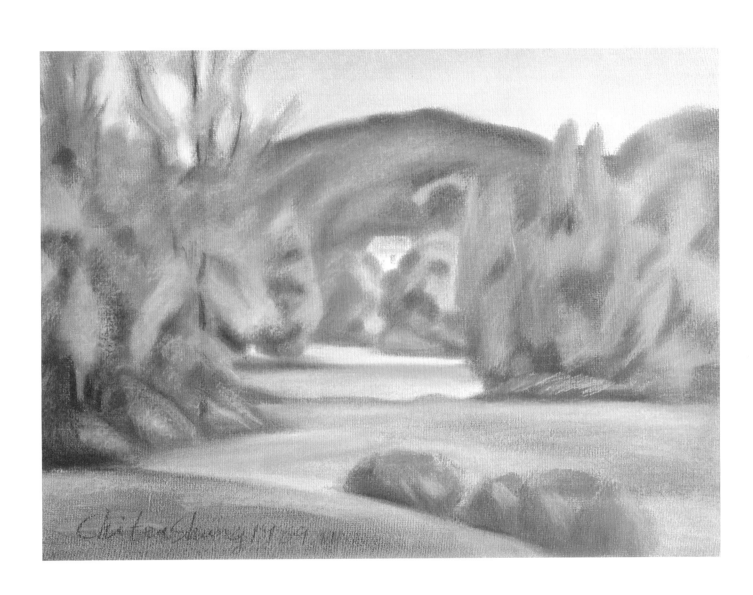

山色 Mountain
1989
紙本粉彩 pastel on paper
38 x 52 cm

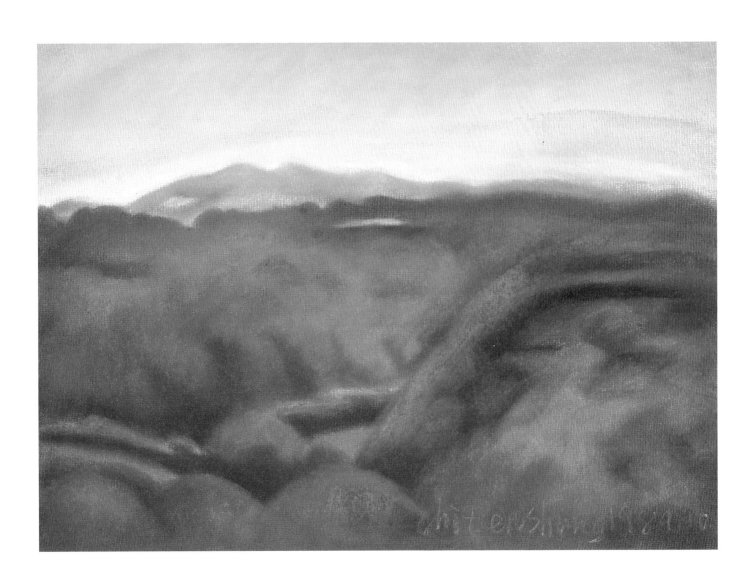

on recto

山區黃昏前

大妹敏子 14 歲由山區越過前山逃離養父母的農家

Mountain before dusk

The eldest sister Minzi escaped the farm of her adoptive parents by crossing the front mountain at the age of 14

通霄愛哭寮（隘口寮）Tungshiau Aikouliao
1990
紙本粉彩 pastel on paper
30 x 40 cm

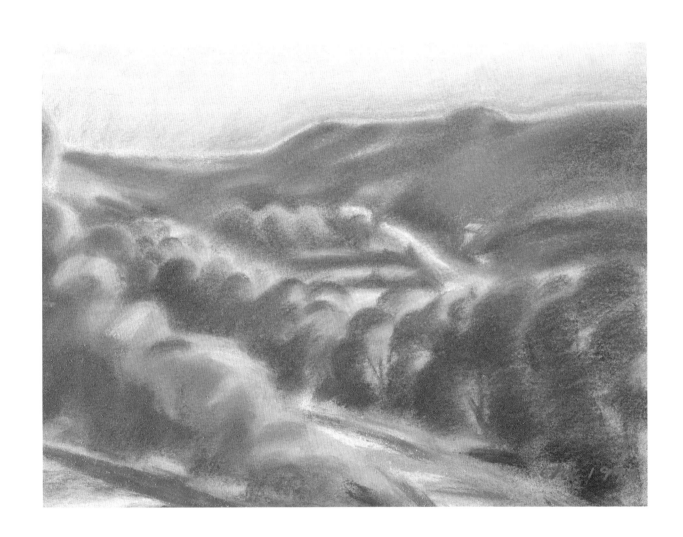

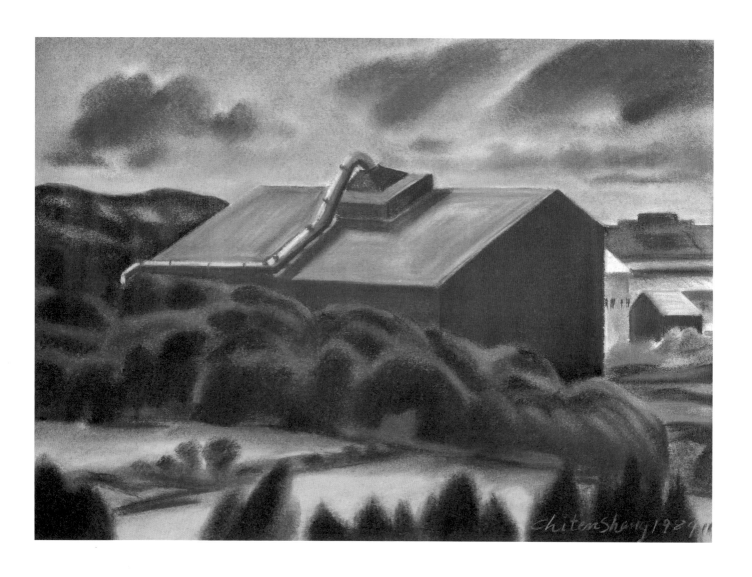

座落在鄉下的工廠之二 Factory in the Countryside II
1989
紙本粉彩 pastel on paper
38.5 x 54 cm

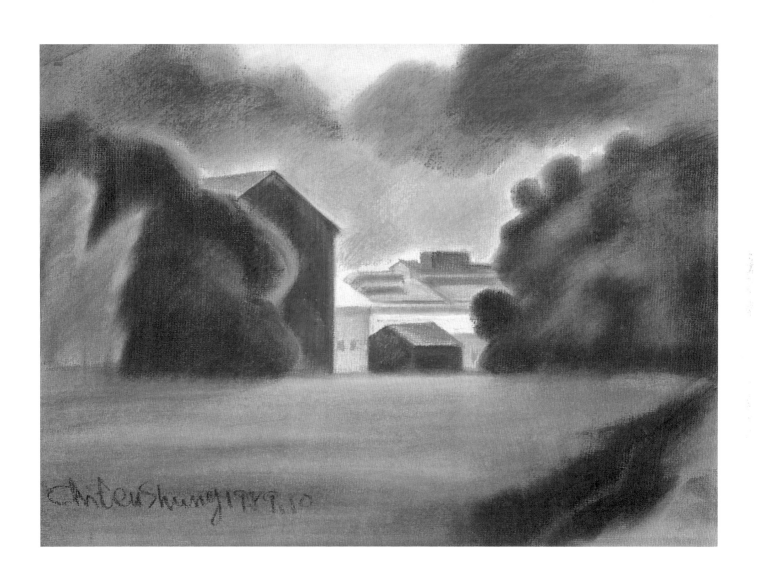

座落在鄉下的工廠之三 Factory in the Countryside III
1989
紙本粉彩 pastel on paper
38 x 52 cm

紅玫瑰 Red Roses
1989.12
紙本粉彩 pastel on paper
39 x 54 cm

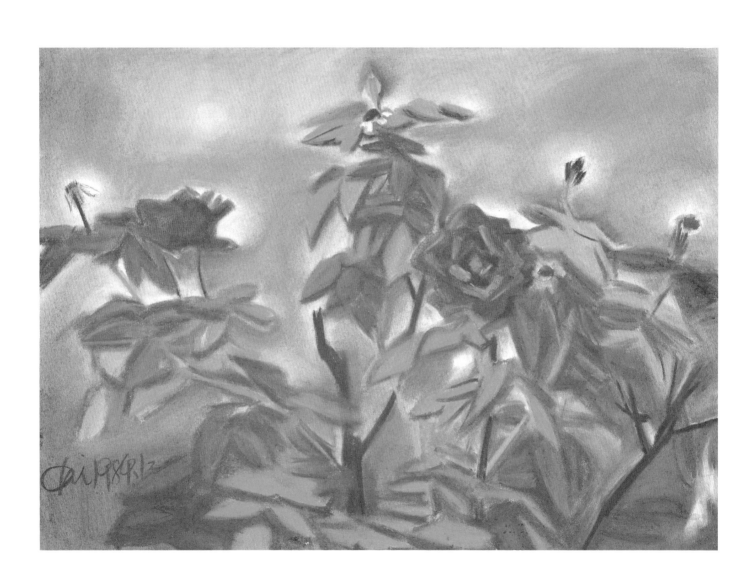

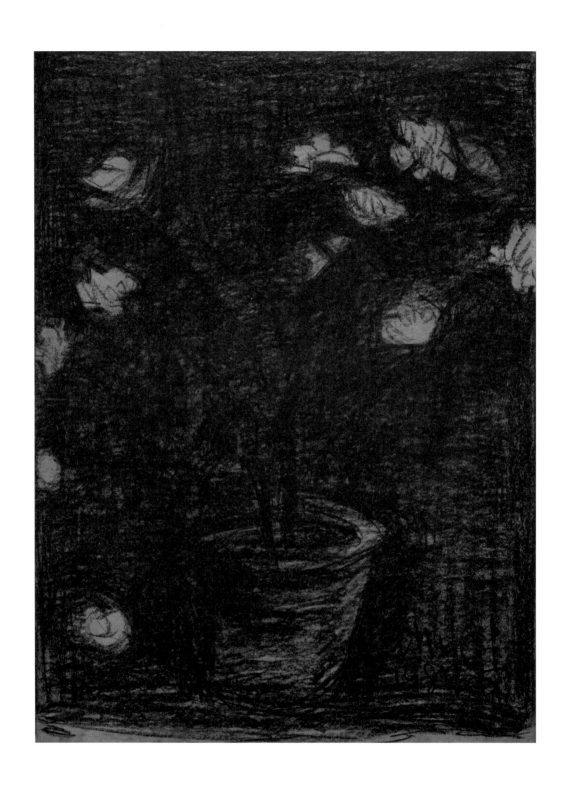

夜晚開的花 Flowers at Night
1989
紙本粉彩 pastel on paper
51.5 x 38.5 cm

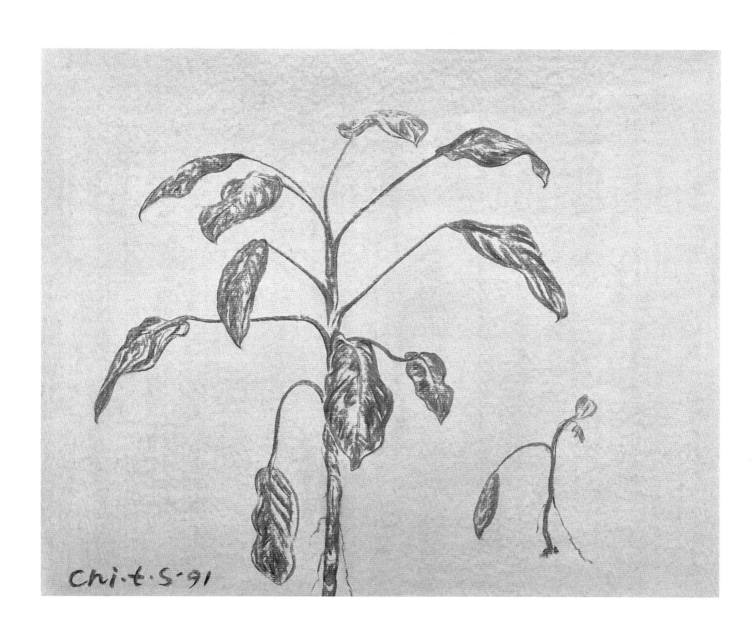

盆栽 Plants
1991
紙本炭筆 charcoal on paper
81 x 101.5 cm

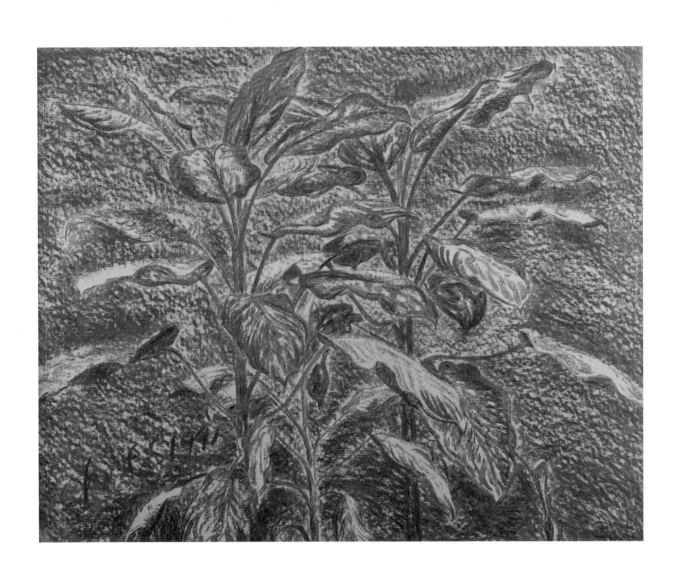

盆栽 Plants
1991
紙本炭筆 charcoal on paper
80 x 100 cm

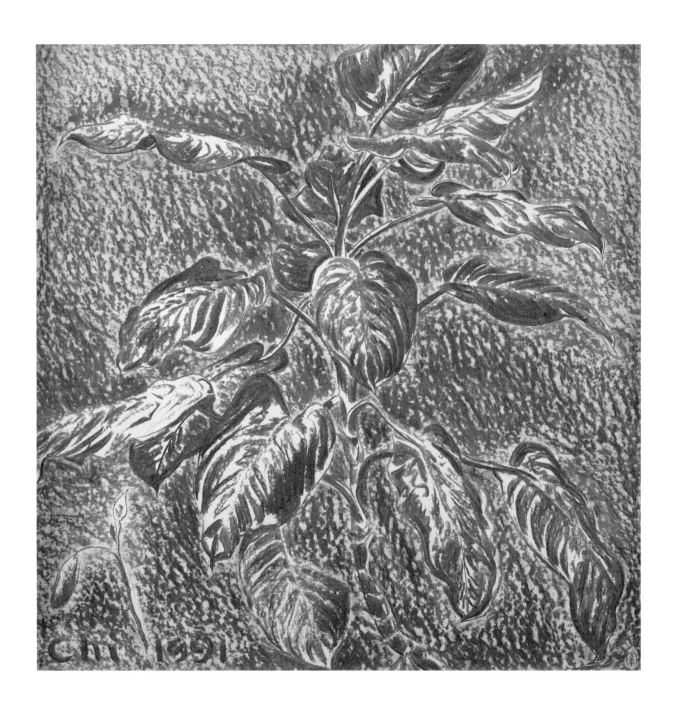

盆栽 Plants
1991
紙本炭筆 charcoal on paper
79 x 79 cm

酒瓶與酒杯 A Bottle and a Glass
1989
紙本粉彩 pastel on paper
39 x 54 cm

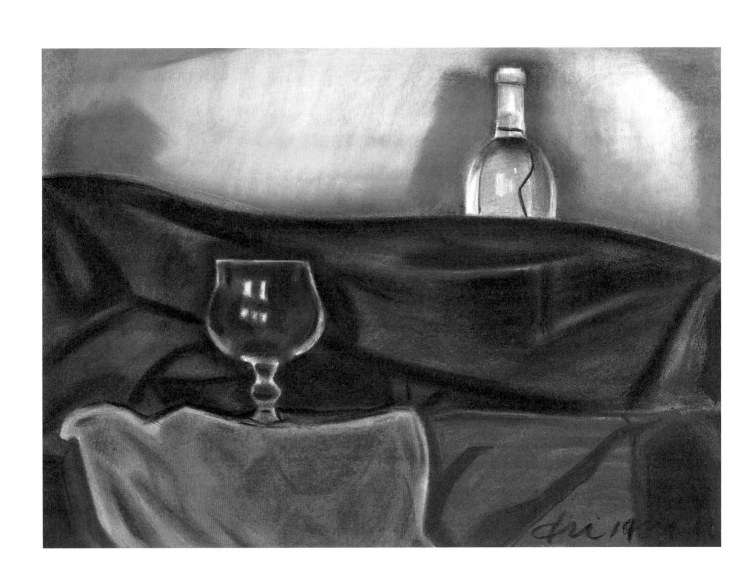

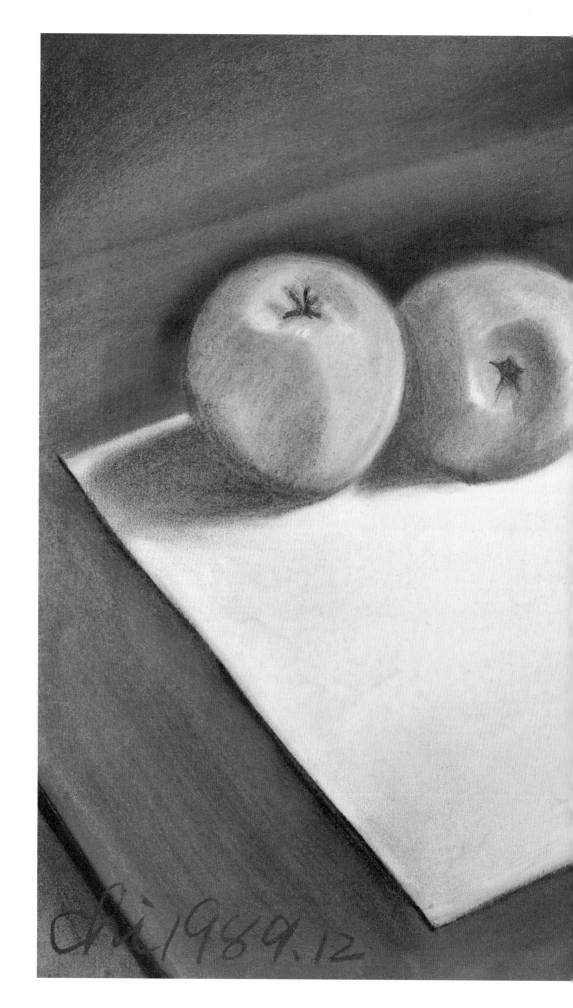

綠蘋果與刀
Green Apples and a Knife
1989.12
紙本粉彩 pastel on paper
38.5 x 54 cm

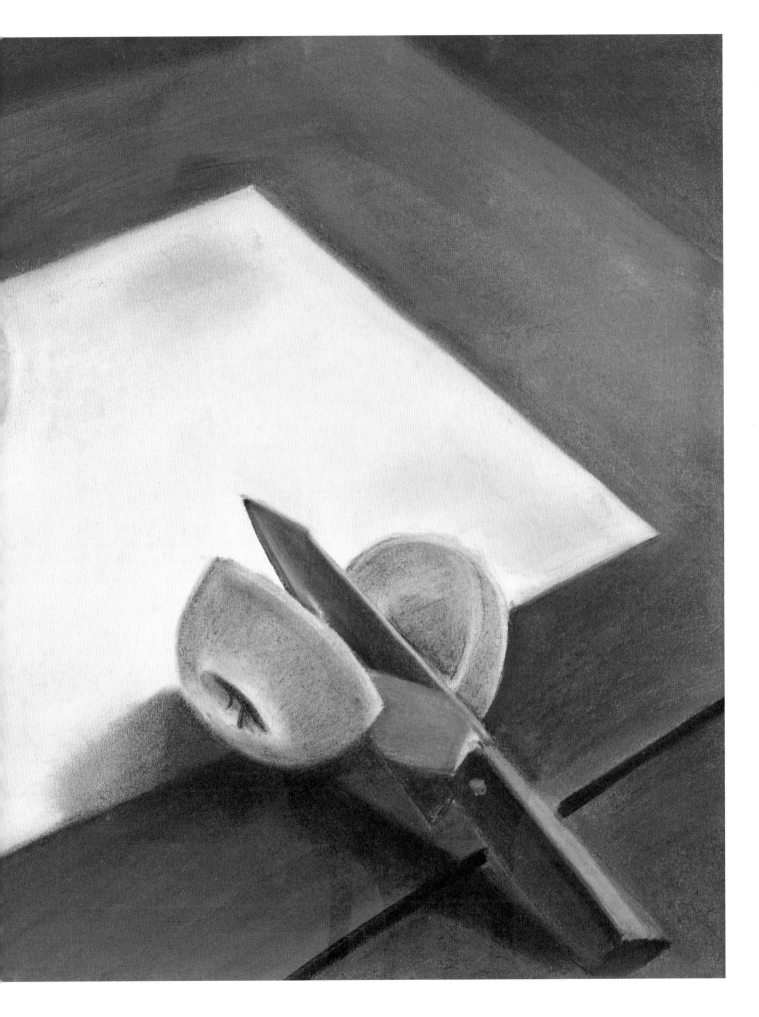

自畫像 Self-portrait
1990
紙本油性粉彩 oily pastel on paper
47.5 x 47.5 cm

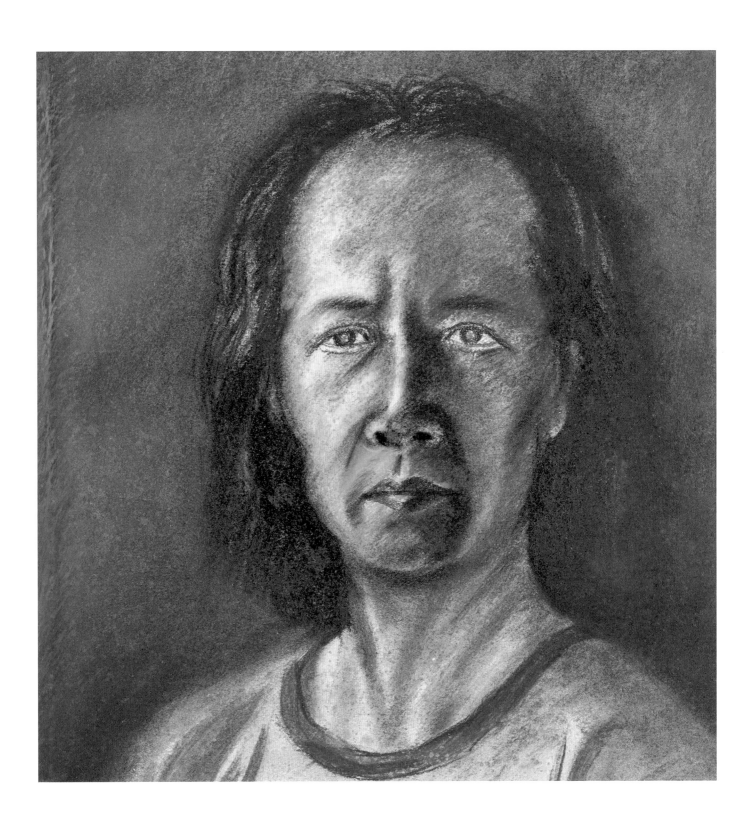

自畫像 Self-portrait
1991
紙本粉彩 pastel on paper
33 x 33 cm

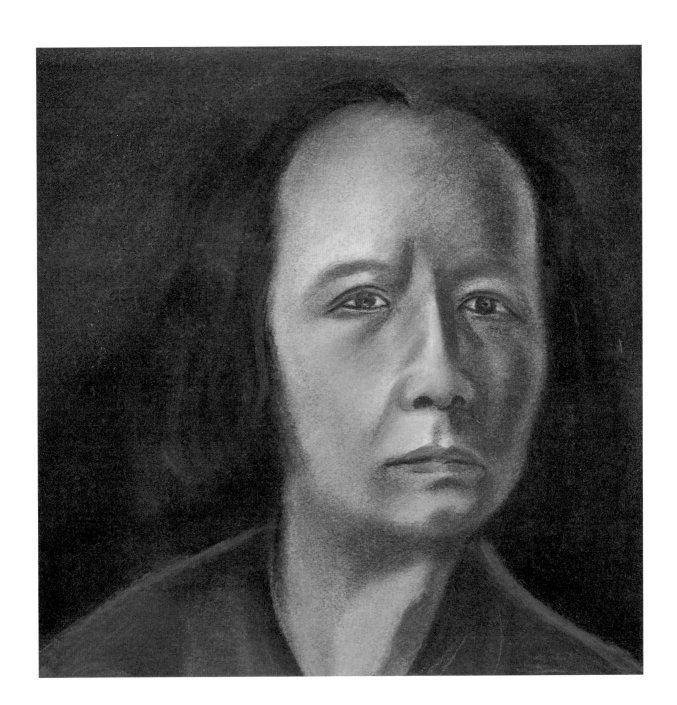

無題 Untitled
1992
紙本油彩 oil on paper
39.5 x 39.5 cm

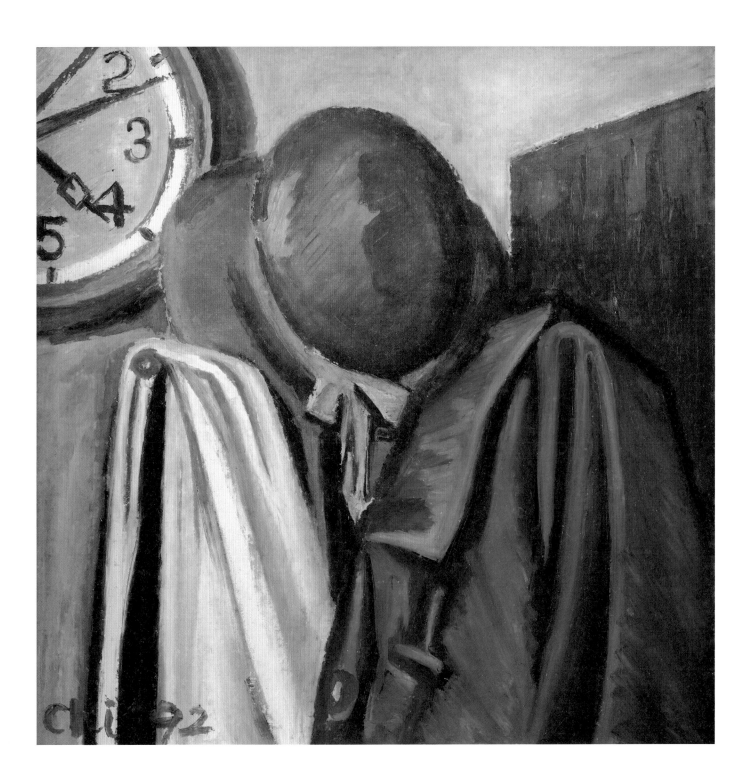

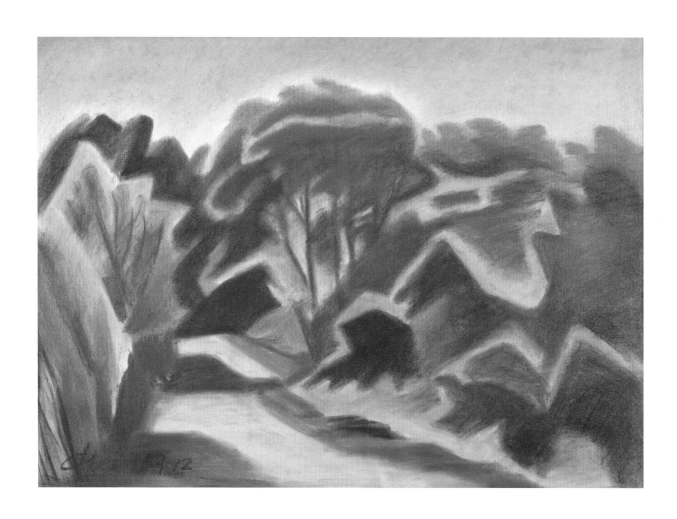

山林 Forest
1989.12
紙本粉彩 pastel on paper
39 x 54 cm

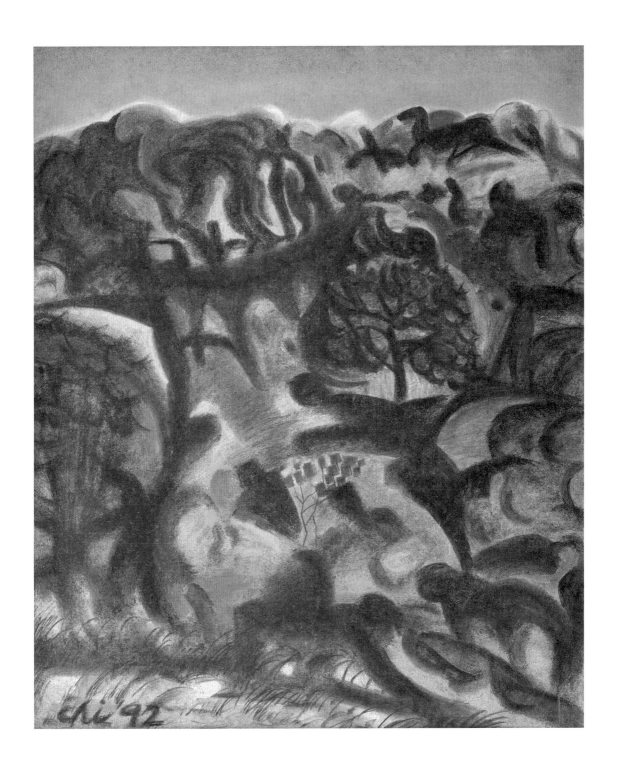

山坡的樹木 Trees of Hillside
1992
紙本粉彩 pastel on paper
58.5 x 48 cm

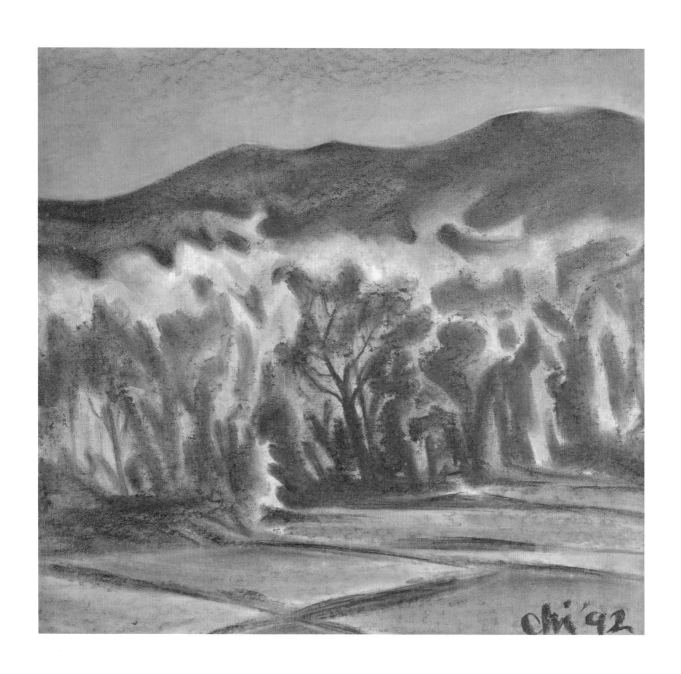

家鄉風景 Hometown
1992
紙本粉彩 pastel on paper
51 x 55 cm

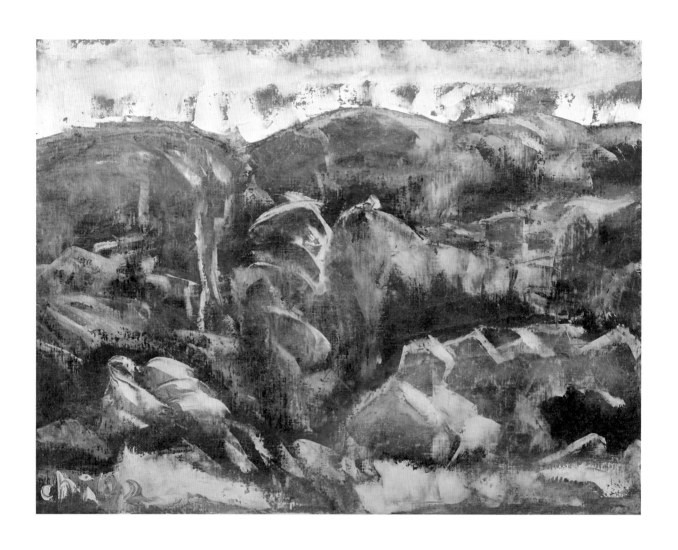

山坡雜木 Woods
1992
紙本油彩 oil on paper
47.5 x 62.5 cm

無題 Untitled
1992
紙本油彩 oil on paper
39.5 x 39.5 cm

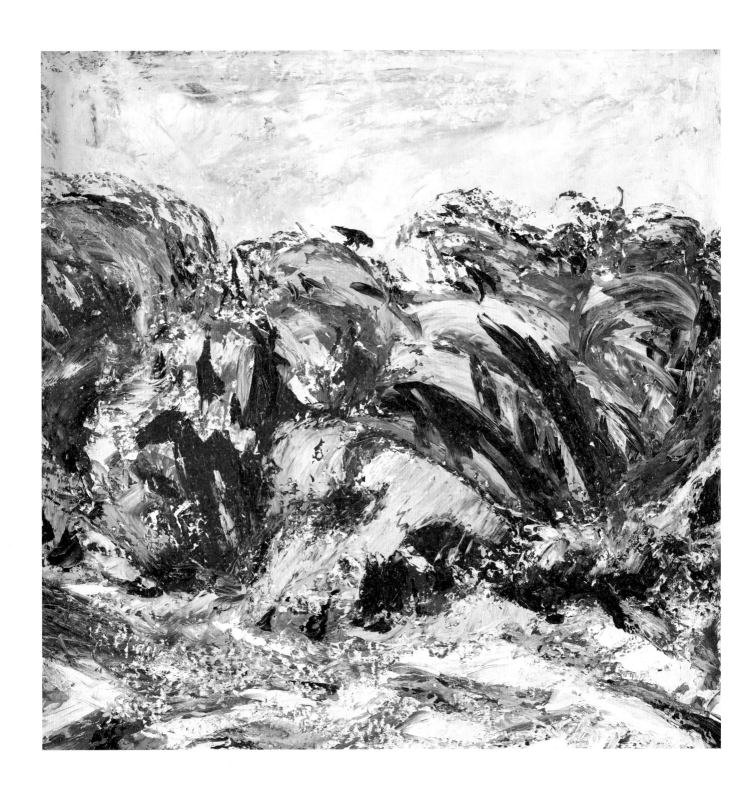

林中受教 Receive an Education in the Forest
1992
紙本油彩 oil on paper
45 x 45 cm

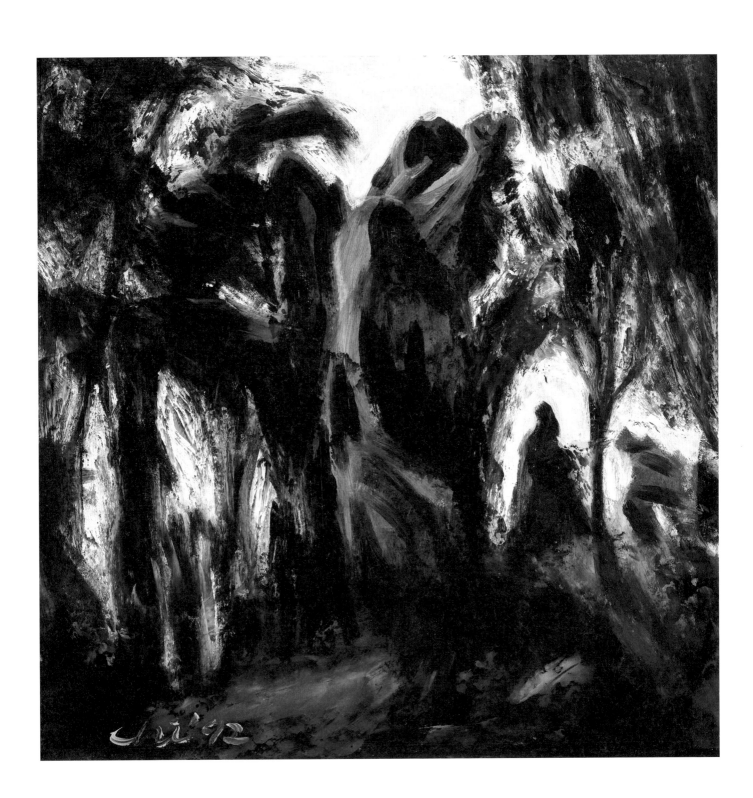

為何堅持 What for Insist On?
1992
紙本油彩 oil on paper
39 x 39 cm

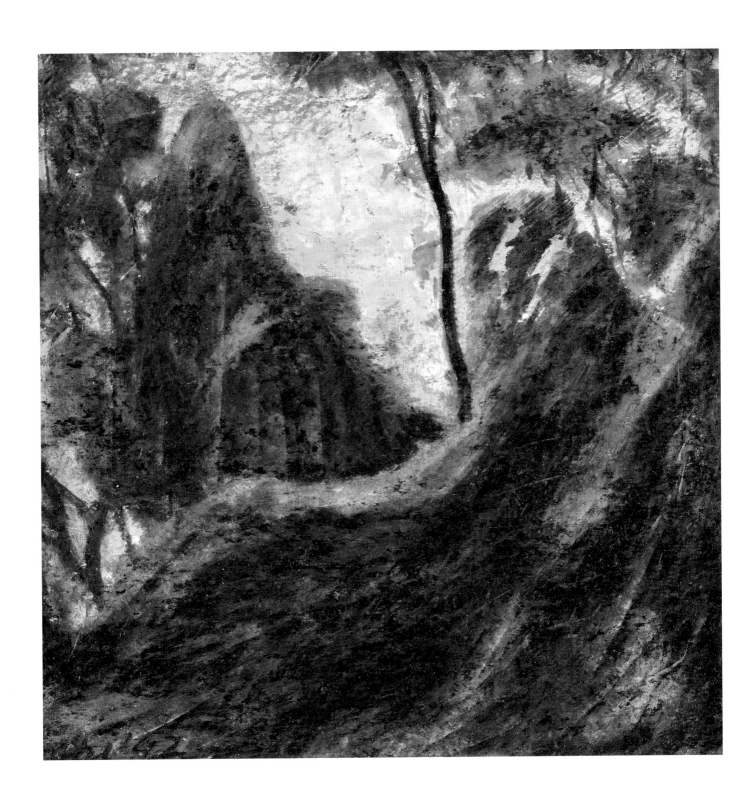

My daughter often accompanied me to the seabeach for a walk in last winter, but now I walk alone.
I want to tell her the art is just like a mood from the memory.

天與地的現象 The Phenomenon of Heaven and Earth
1992
紙本油彩 oil on paper
45 x 45 cm

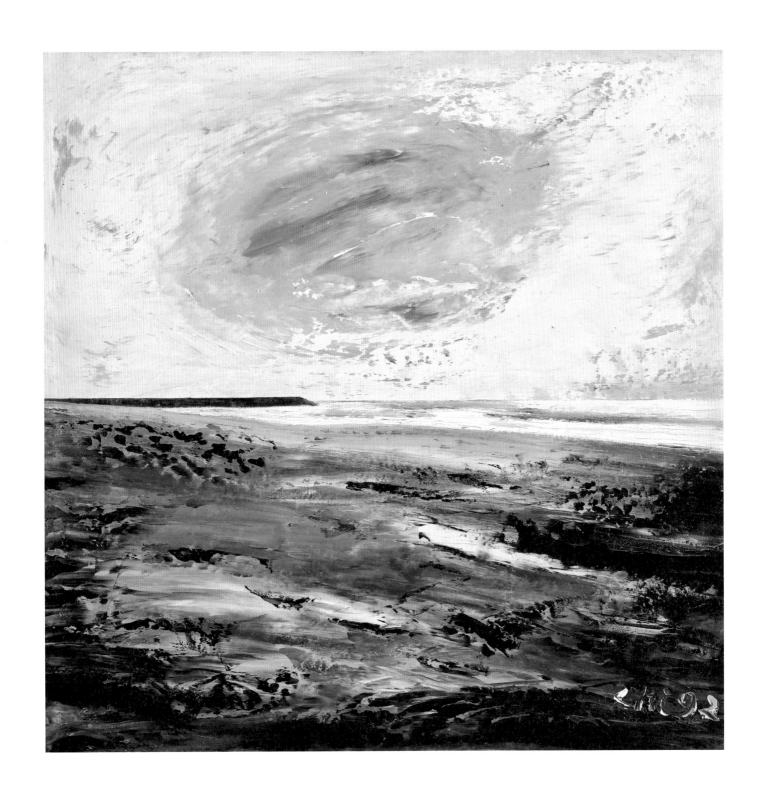

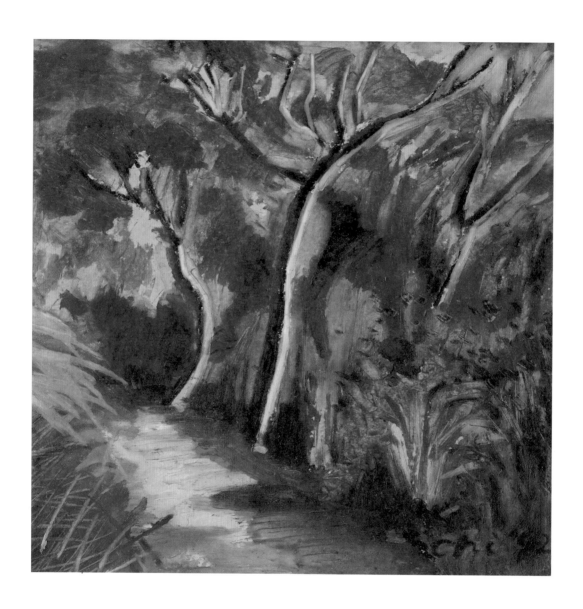

山林路段 A Certain Somewhere Over the Road of Mountain Forest
1992
紙本油彩 oil on paper
28 x 28 cm

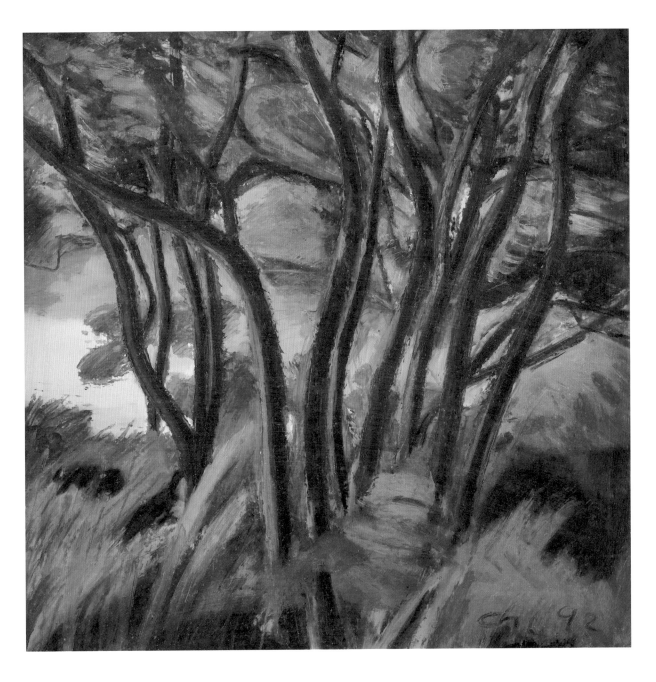

*on verso*

My daughter from outer island to native soil yesterday.

Today, I drive north up, she and mother south down by the train. We are meet at Shin Jwu city.

After that, we are going to the Engineering College to see her brother. We have two hours together and lunch in car.

林中水池 The Pond Beyond the Forest
1992
紙本油彩 oil on paper
44 x 44 cm

降臨一 Befallen
1992
紙本油彩 oil on paper
45 x 45 cm

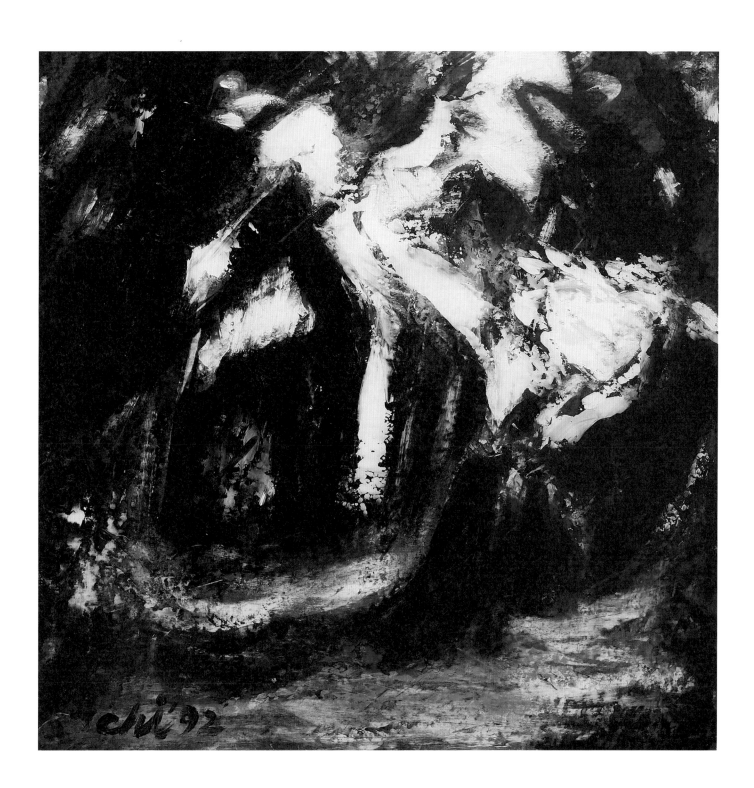

是迎迓或威嚇？ Is it Welcome or Intimidation?
1992
紙本油彩 oil on paper
39 x 39 cm

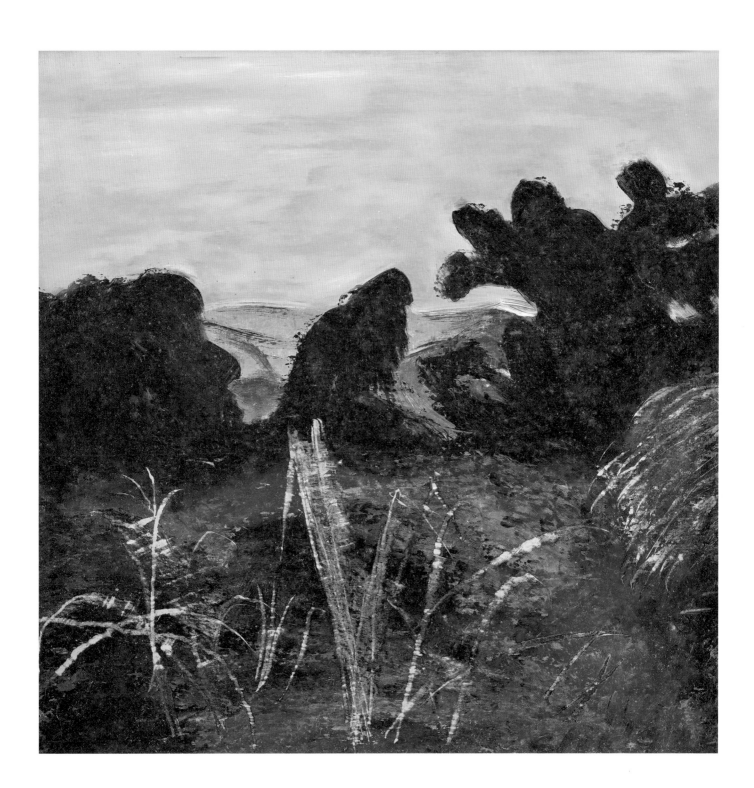

*on verso*

Polo telephoned me last night, words midway he choked with sobs, I said what things for, he speak disjointedly :

I think of you'd worry about me. I responded:  Yes, it is naturally.

舉高作飛狀 Hold up to Fly High
1992
紙本油彩 oil on paper
52 x 52 cm

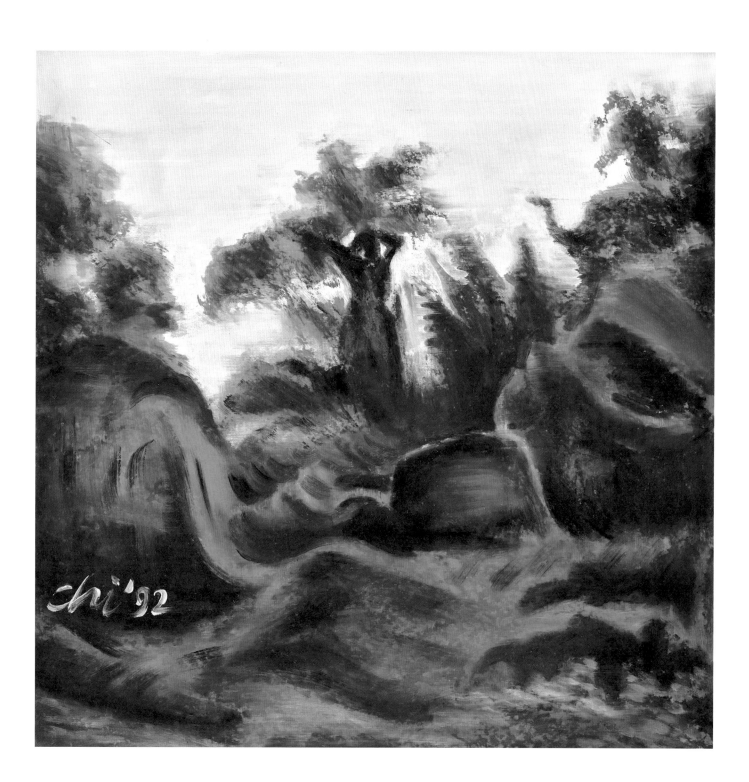

瞻望與默念之處 The Place of Looking Forward with Silent Missing
1992
紙本油彩 oil on paper
39 x39 cm

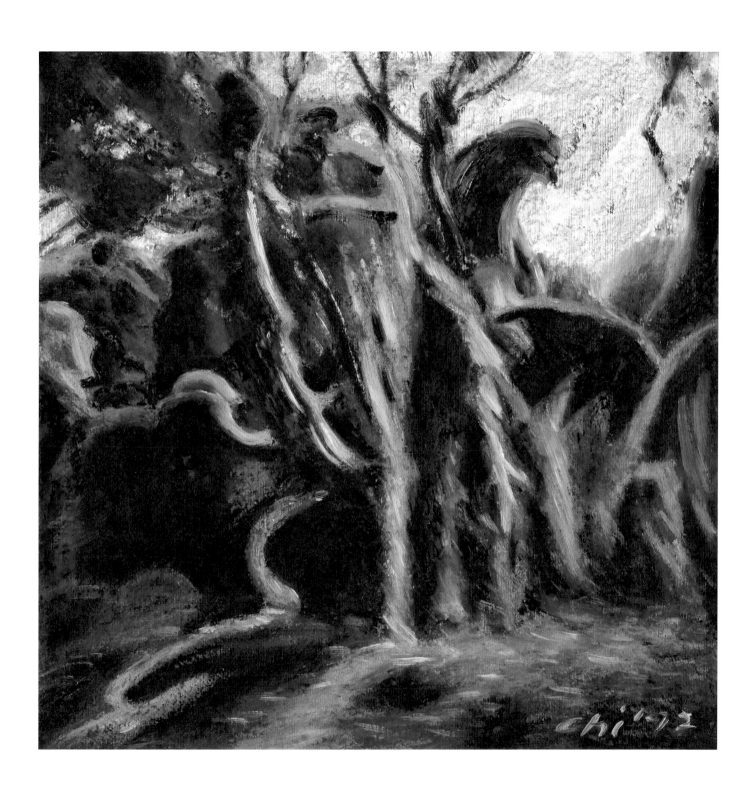

莽草的上層 The Upper State of the Ranking Grass
1992
紙本油彩 oil on paper
41 x 41 cm

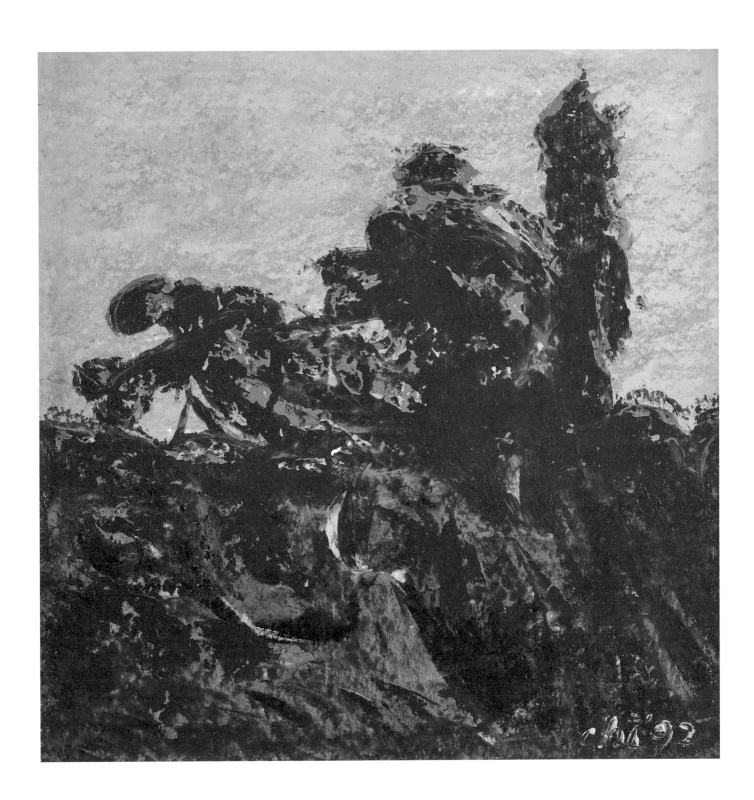

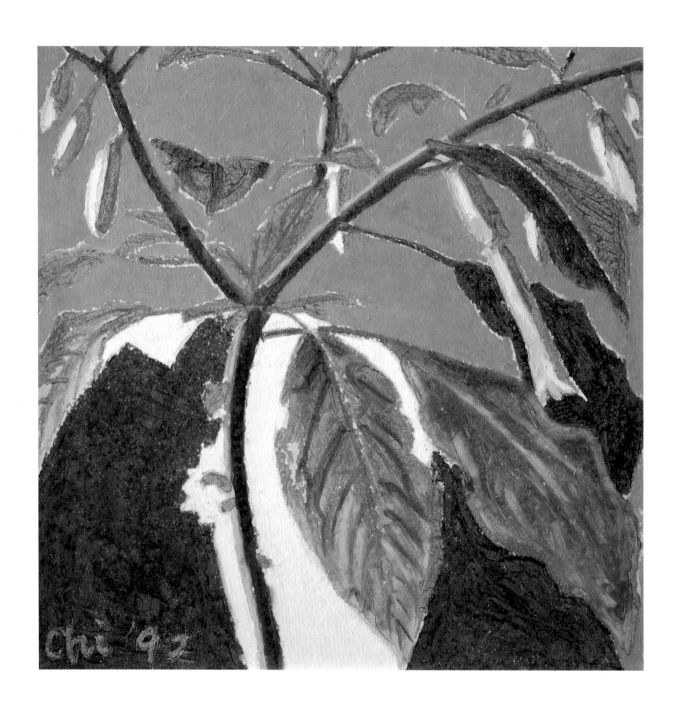

葉下交談 Conversation Under the Leaves
1992
紙本油彩 oil on paper
43 x 43 cm

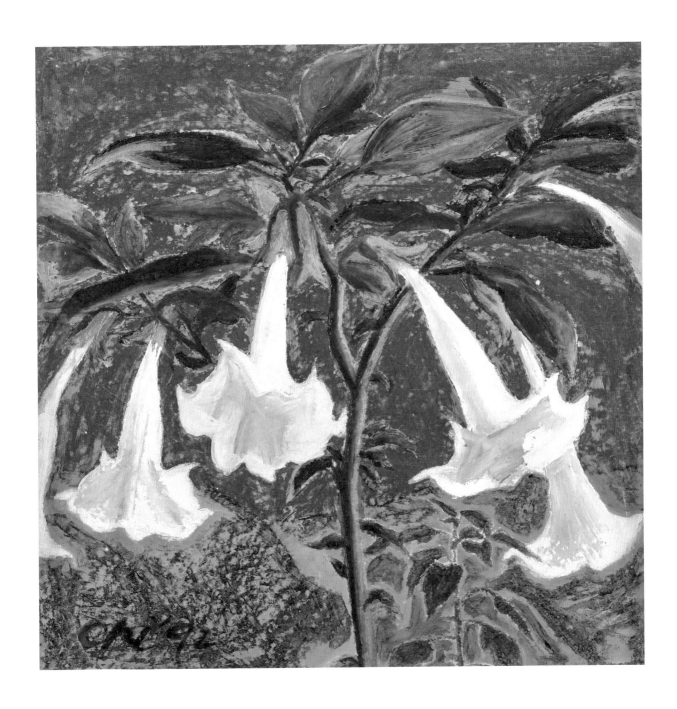

忝為花癡偏嗜白，
葉下交談弱株哀；
自來裙裡多黯然，
猶似紅天落紛藍。

Being the flowerwarn has a partiality for white,
and the conversation of the mourning weak plant under the leaves;
from the beginning the skirt underheath the most dim,
just as the red sky fallen disorderly blue.
1992
紙本油彩 oil on paper
53 x 53 cm

跳舞 Dancing
1992
紙本油彩 oil on paper
44 x 44 cm

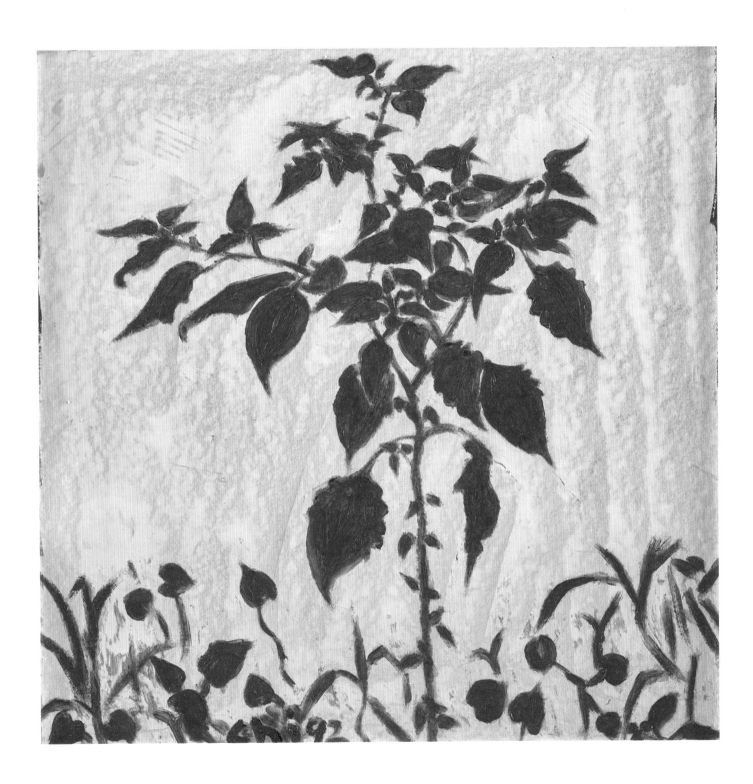

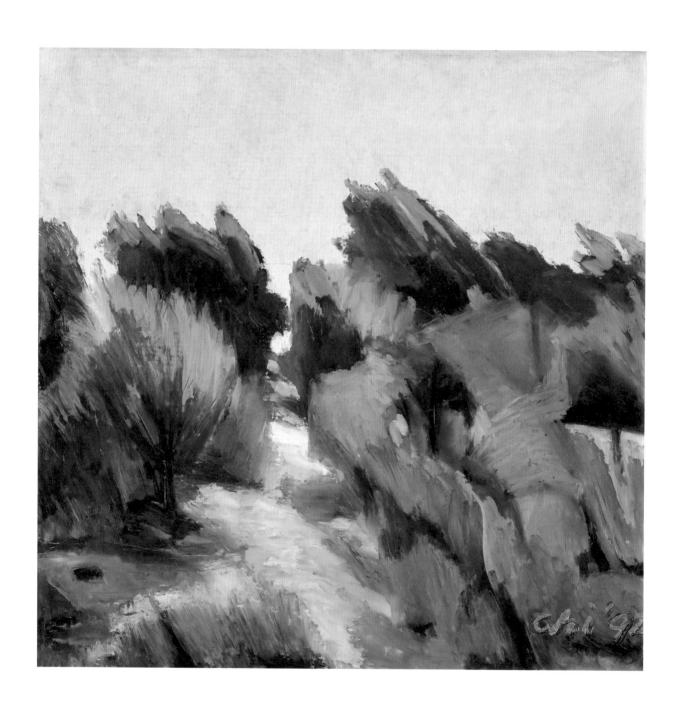

穿過雜草和樹叢 Through Grass and Grove
1992
紙本油彩 oil on paper
39 x 39 cm

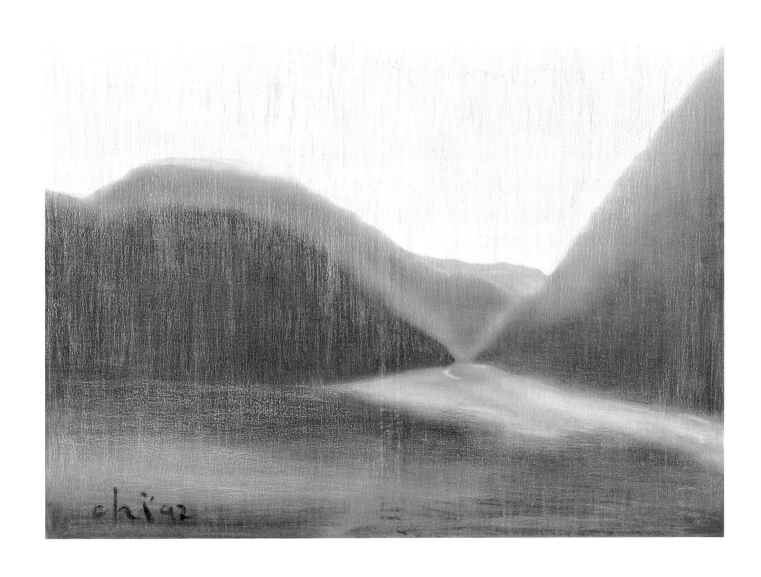

家鄉的山景 Landscapes of Hometown
1992
布面油彩 oil on canvas
64.5 x 90 cm

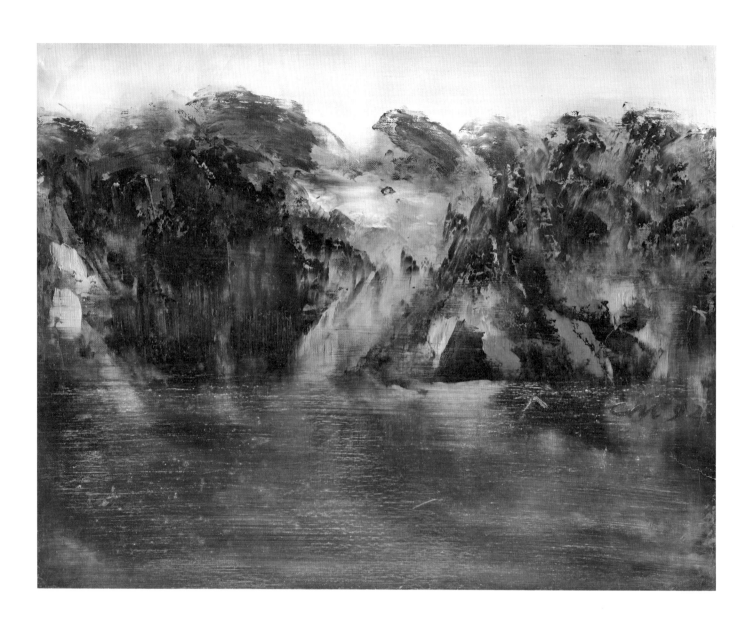

有龍在淵 A Dragon in Abyss
1992
紙本油彩 oil on paper
38.5 x 49 cm

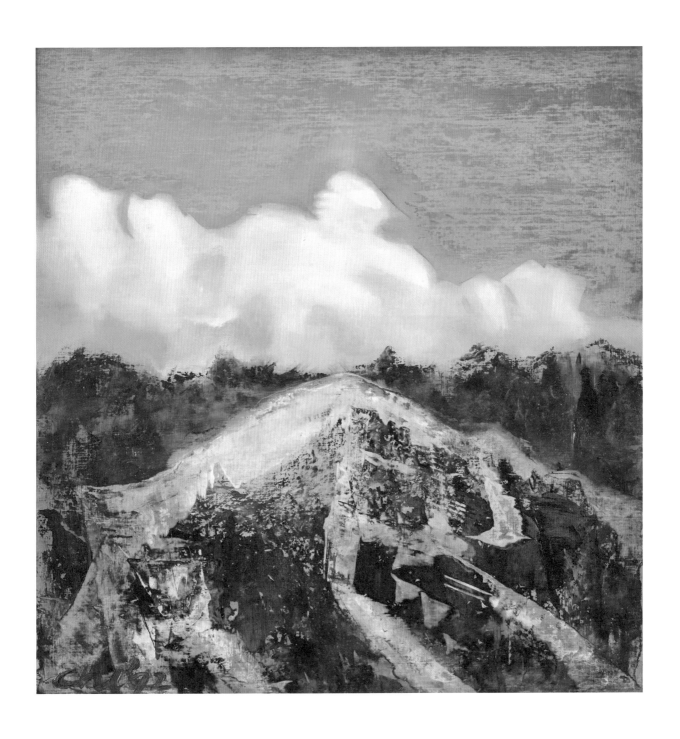

雲 Clouds
1992
布面油彩 oil on canvas
50 x 48 cm

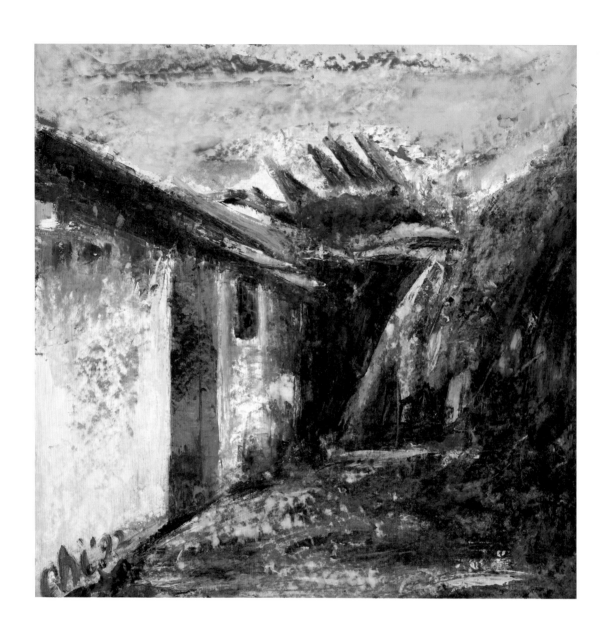

獨居羞情 Alone with a Shy Affection
1992
紙本油彩 oil on paper
35 x 35 cm

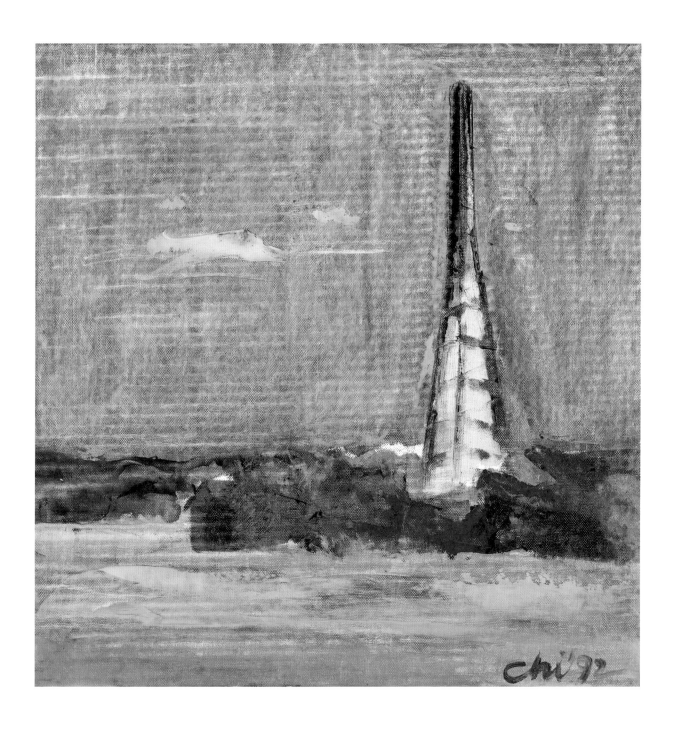

某日路過窯廠 One Day Passing by Bell Kilns
1992
紙本油彩 oil on paper
40 x 40 cm

斑點 The Spots
1992
布面油彩 oil on canvas
40 x 40 cm

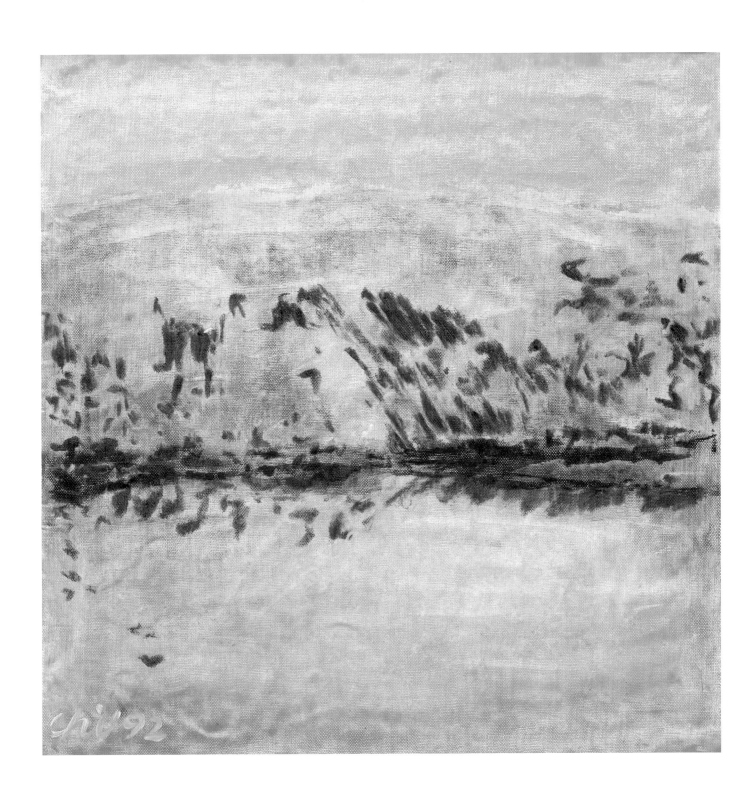

海濱殘夢 The Surviving Dream of Seashore
1992
紙本油彩 oil on paper
45 x 45 cm

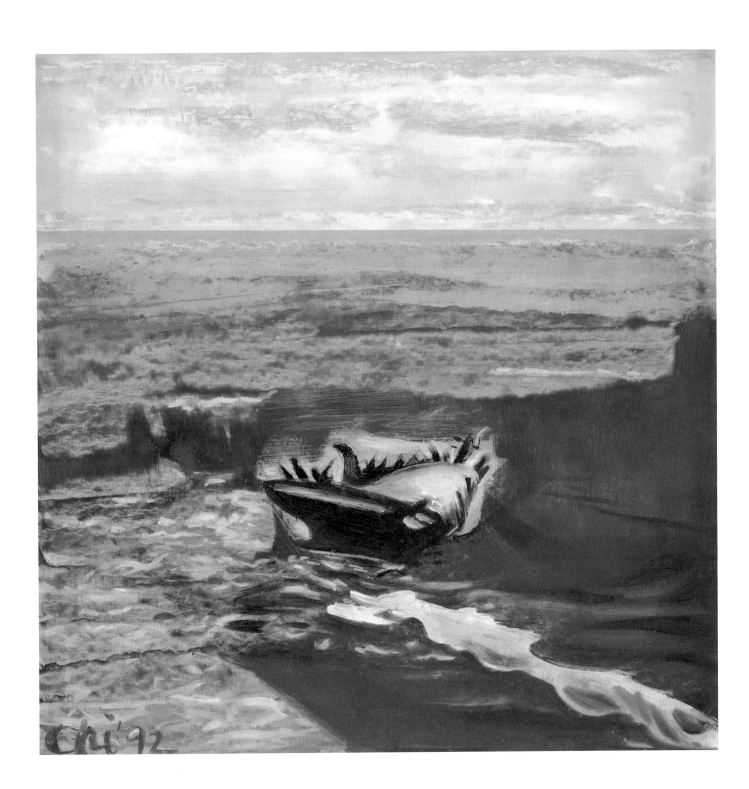

一隻船航行水平線上 A Ship Sails on the Horizontal Line
1992
紙本油彩 oil on paper
45 x 45 cm

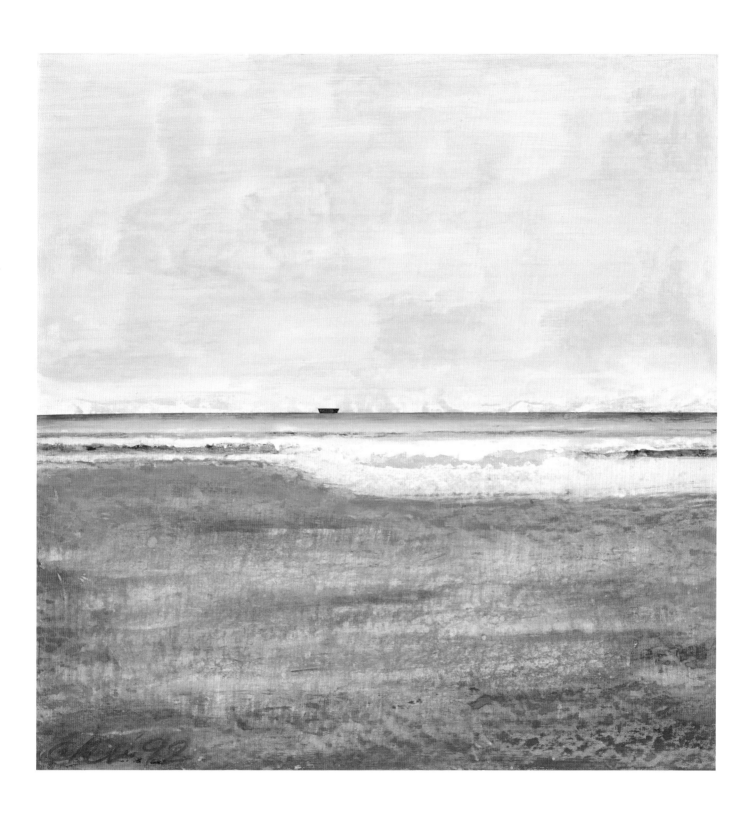

海邊日落映照白石 Seashore's Sunset Shines on the White Stone
1992
紙本油彩 oil on paper
68 x 66 cm

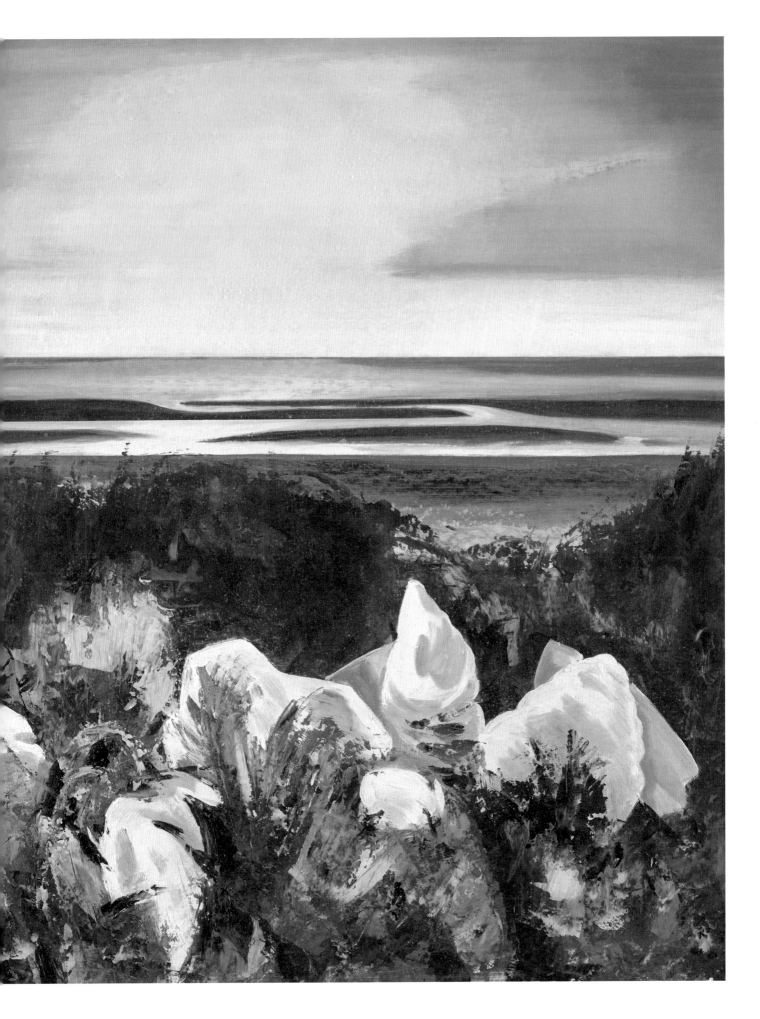

沙地上 On the Sand
1992
紙本油彩 oil on paper
56 x 56 cm

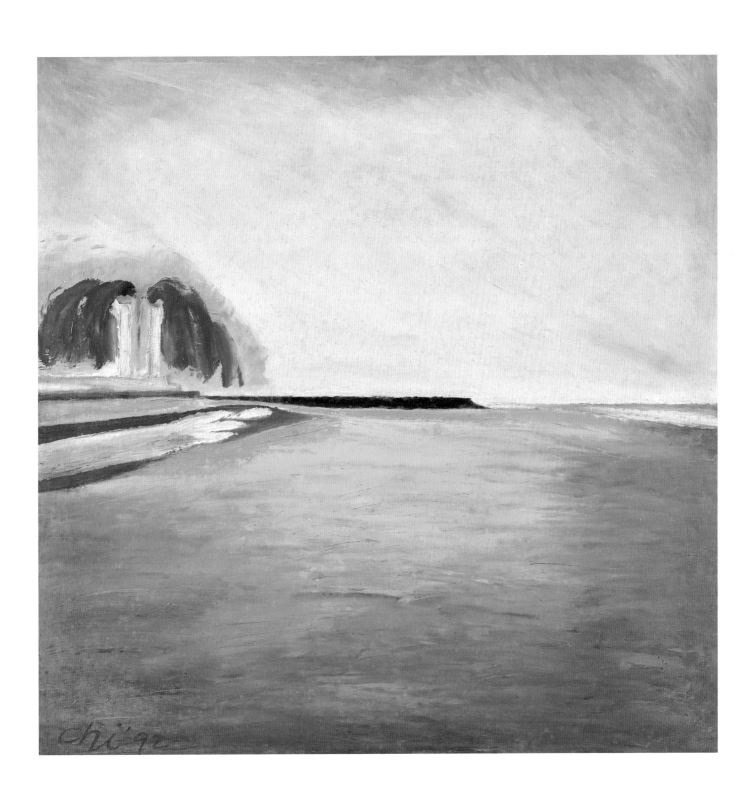

船骸 The Skeleton of Ship
1992
紙本油彩 oil on paper
28 x 28 cm

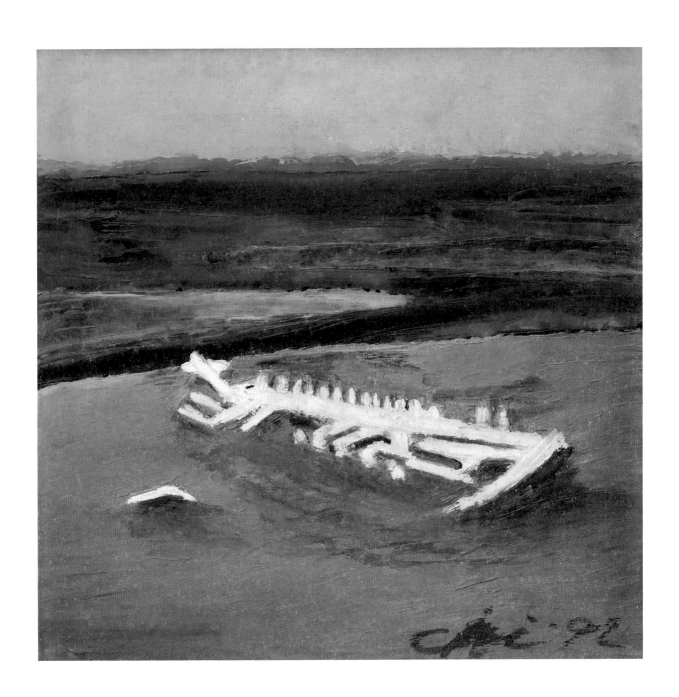

海邊的天空 Sky of Seashore
1992
紙本油彩 oil on paper
64 x 64 cm

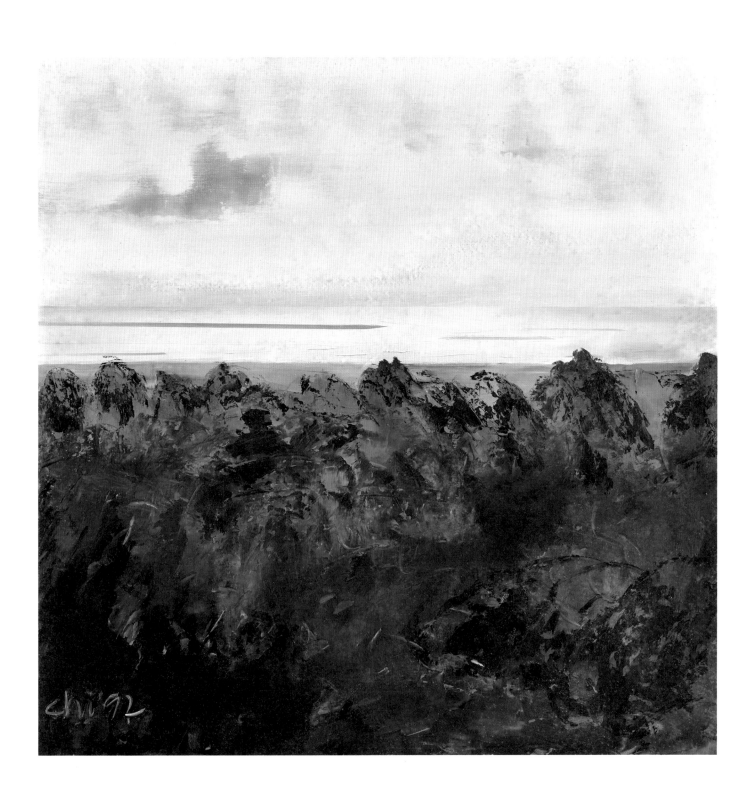

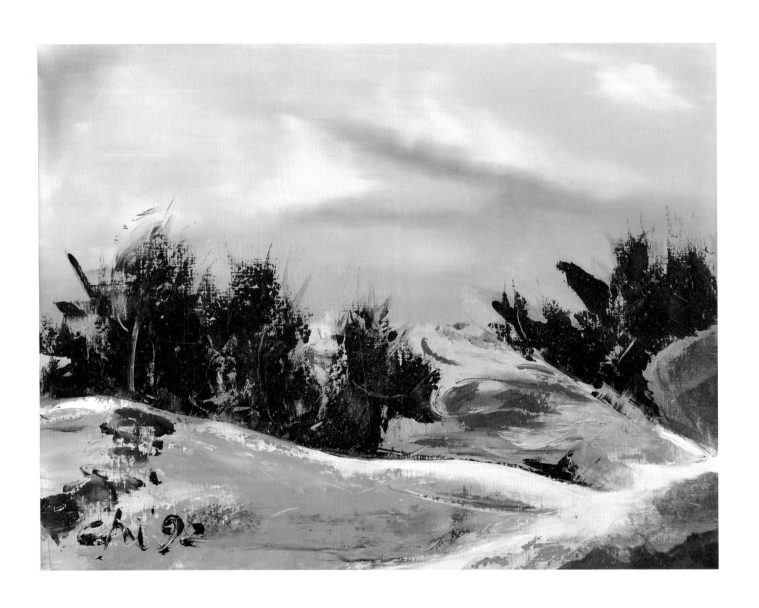

海邊沙丘的草 Grass on the Sand Dune of Seashore
1992
布面油彩 oil on canvas
46.5 x 61 cm

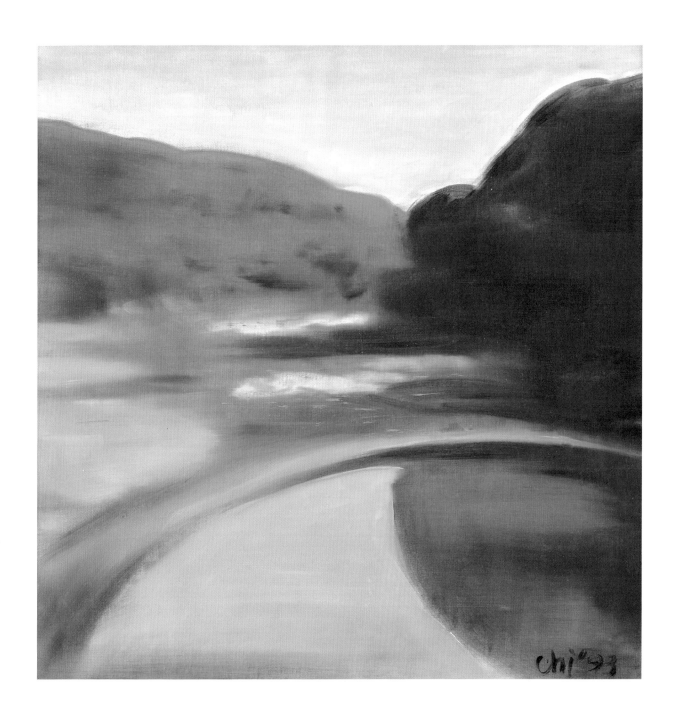

通霄春野 Tungshiau's Spring
1993
布面油彩 oil on canvas
64 x 64 cm

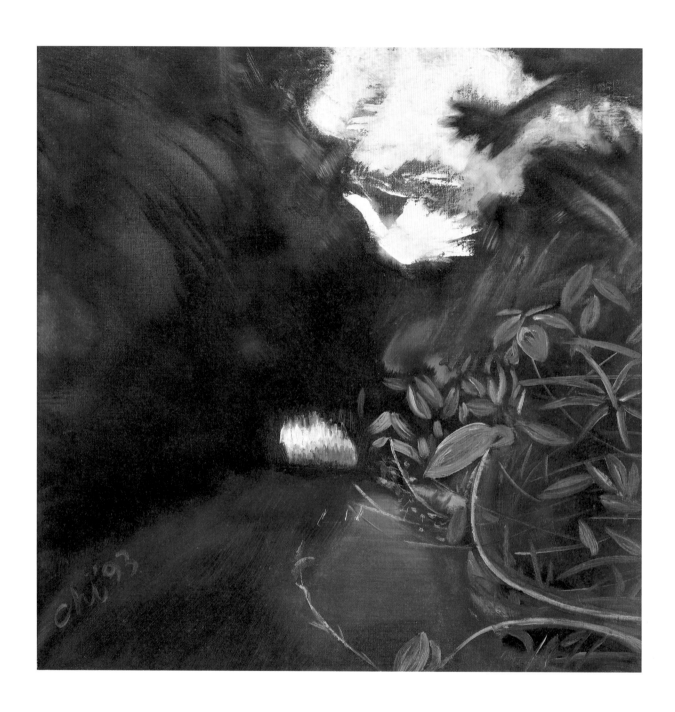

洞 The Hole
1993
布面油彩 oil on canvas
63.5 x 63.5 cm

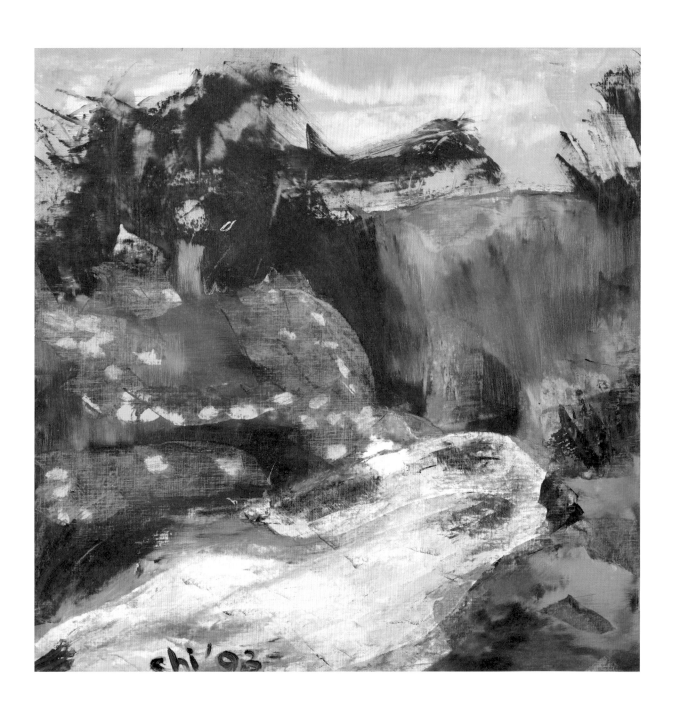

羊兔之間 Between Goat and Rabbit
1993
布面油彩 oil on canvas
64 x 64 cm

降臨二 Befallen II
1993
紙本油彩 oil on paper
60.5 x 60.5 cm

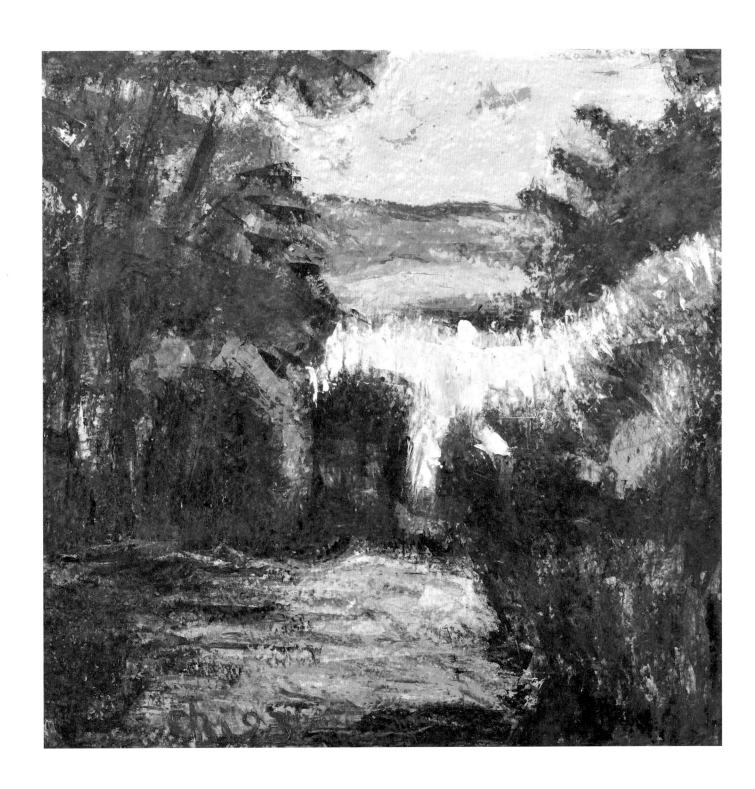

沙河 River
1993
布面油彩 oil on canvas
45 x 45 cm

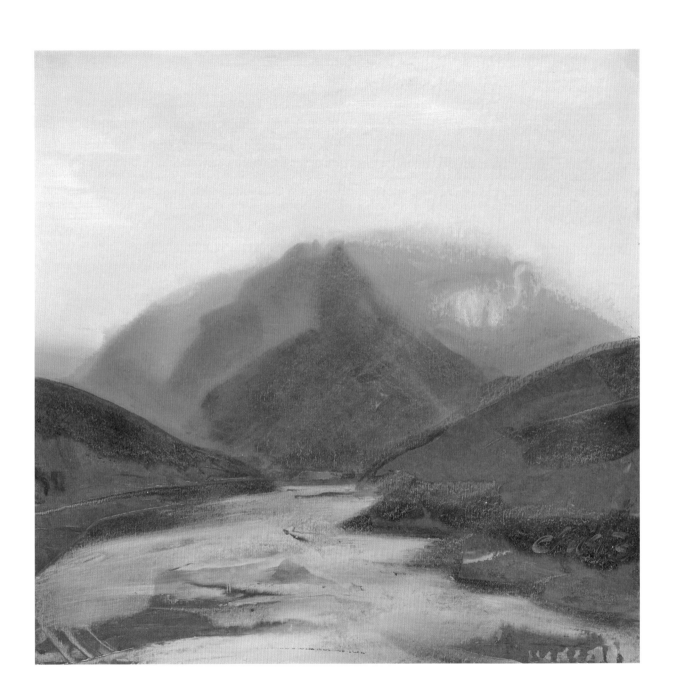

花蓮山 Mountains in Hualien
1993
布面油彩 oil on canvas
80 x 99.5 cm

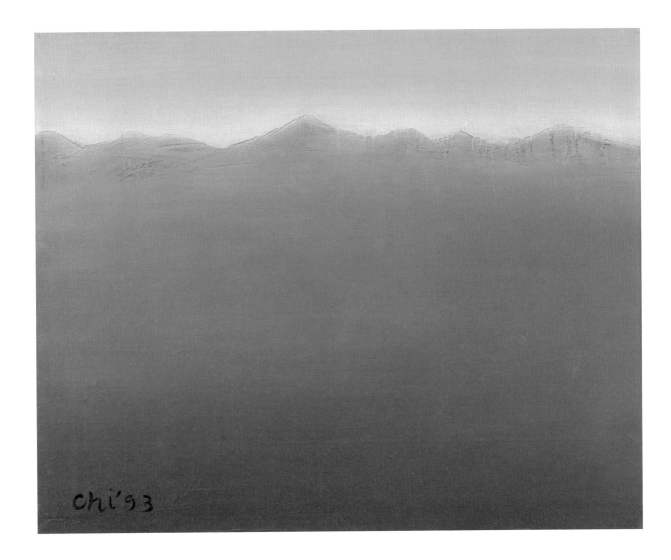

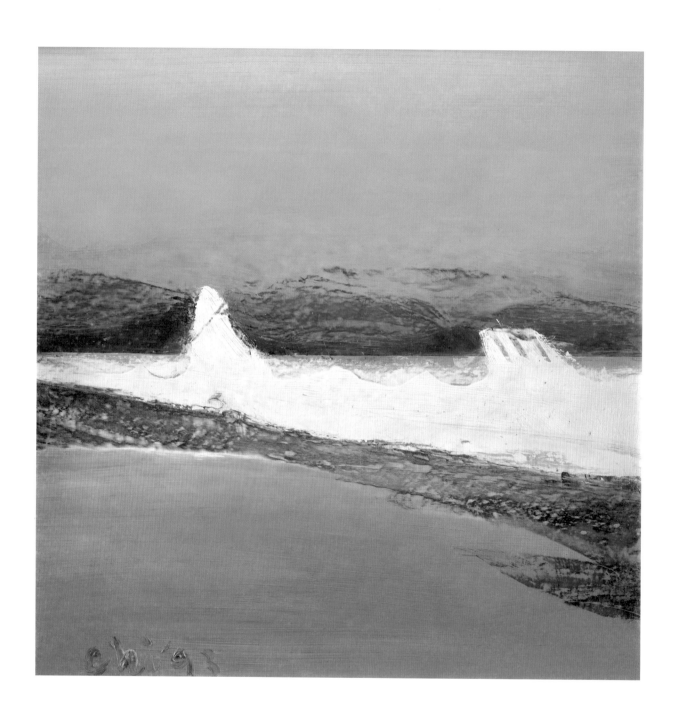

海浪 The Waves
1993
布面油彩 oil on canvas
74 x 74 cm

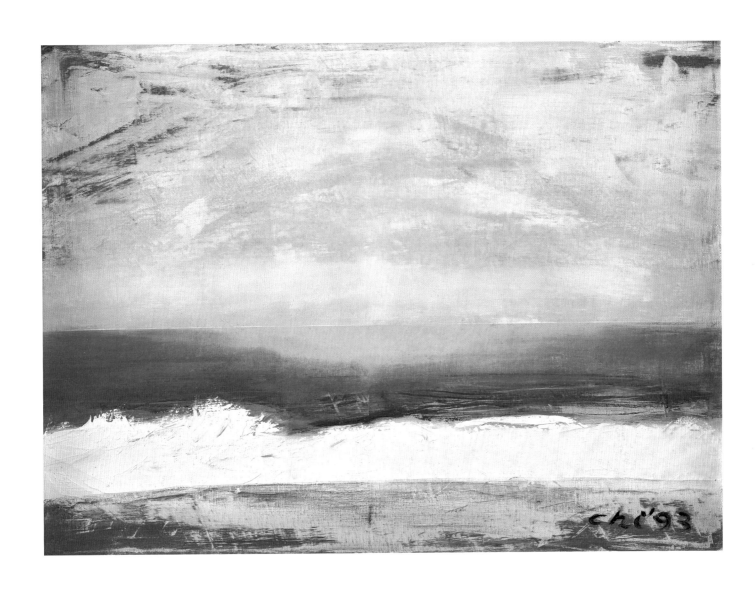

花蓮七星潭 Hualien Qixingtan
1993
布面油彩 oil on canvas
53 x 69 cm

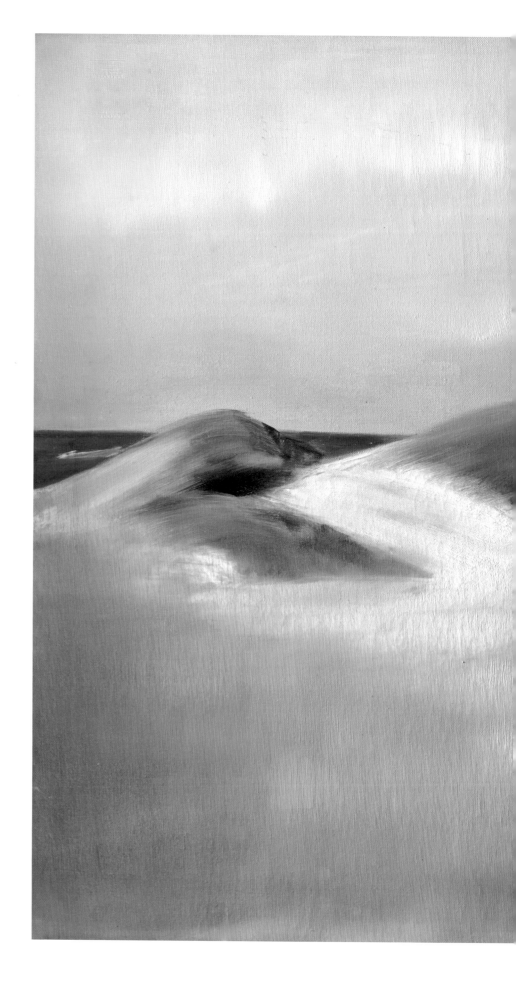

通霄的海邊 Tungshiau's Seashore
1993
布面油彩 oil on canvas
65 x 91 cm

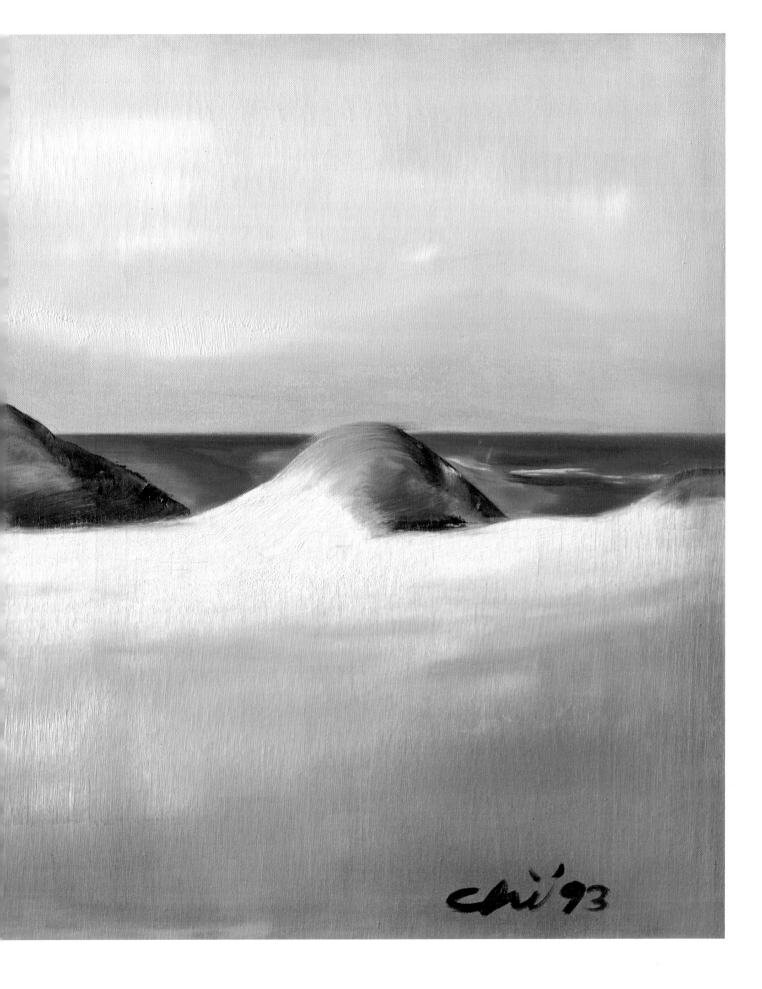

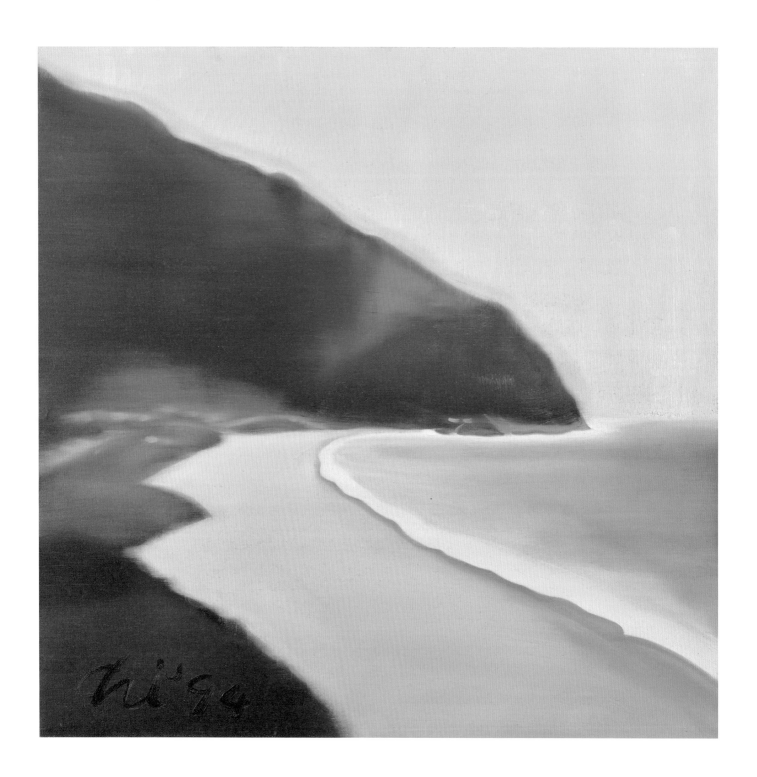

花蓮七星潭 Hualien Qixingtan
1994
布面油彩 oil on canvas
74.5 x 74.5 cm

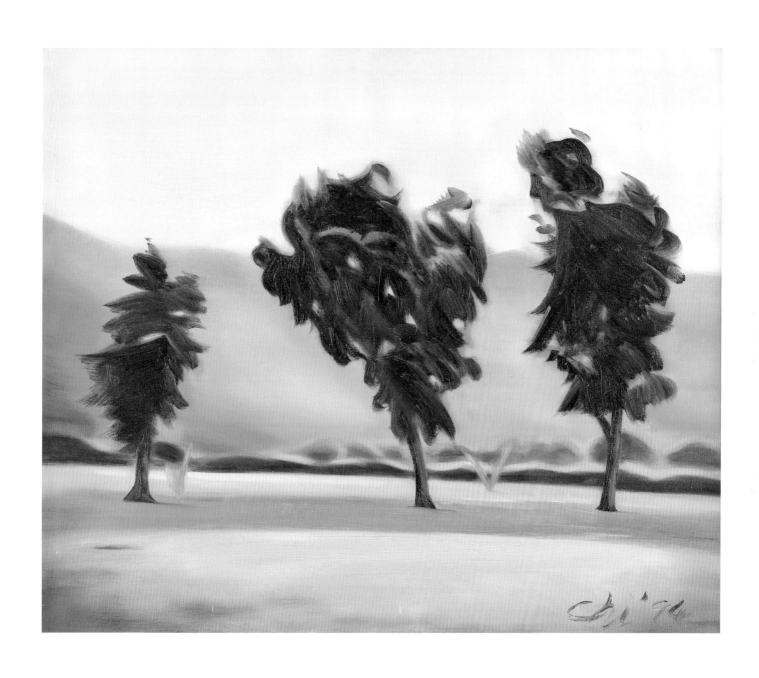

花蓮鯉魚潭 Hualien Liyu Lake
1994
布面油彩 oil on canvas
59.5 x 71.5 cm

花蓮公園 Hualien Park
1994
布面油彩 oil on canvas
75 x 75 cm

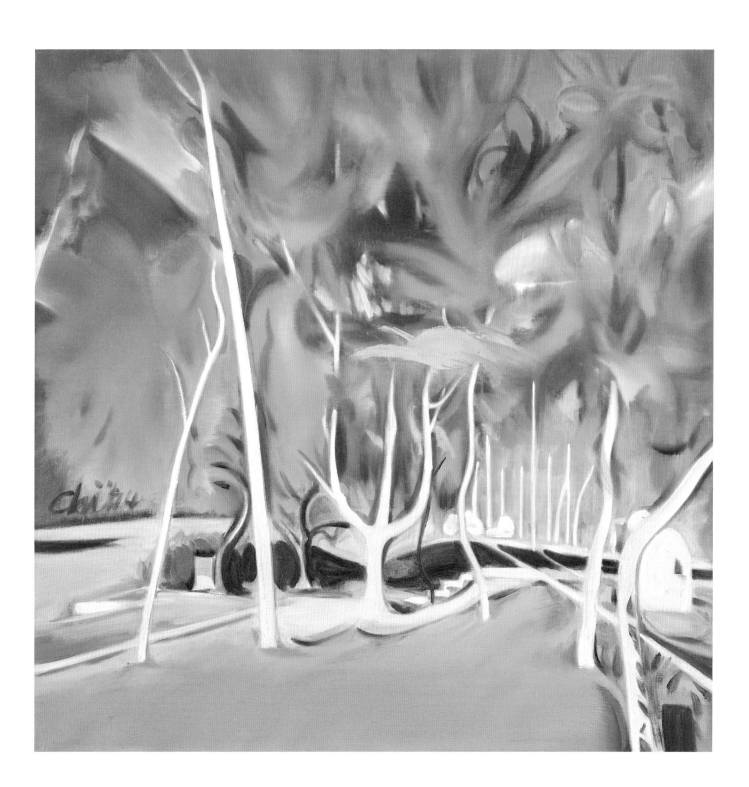

夢鄉 Dream of the Hometown
1994
布面油彩 oil on canvas
74.5 x 74.5 cm

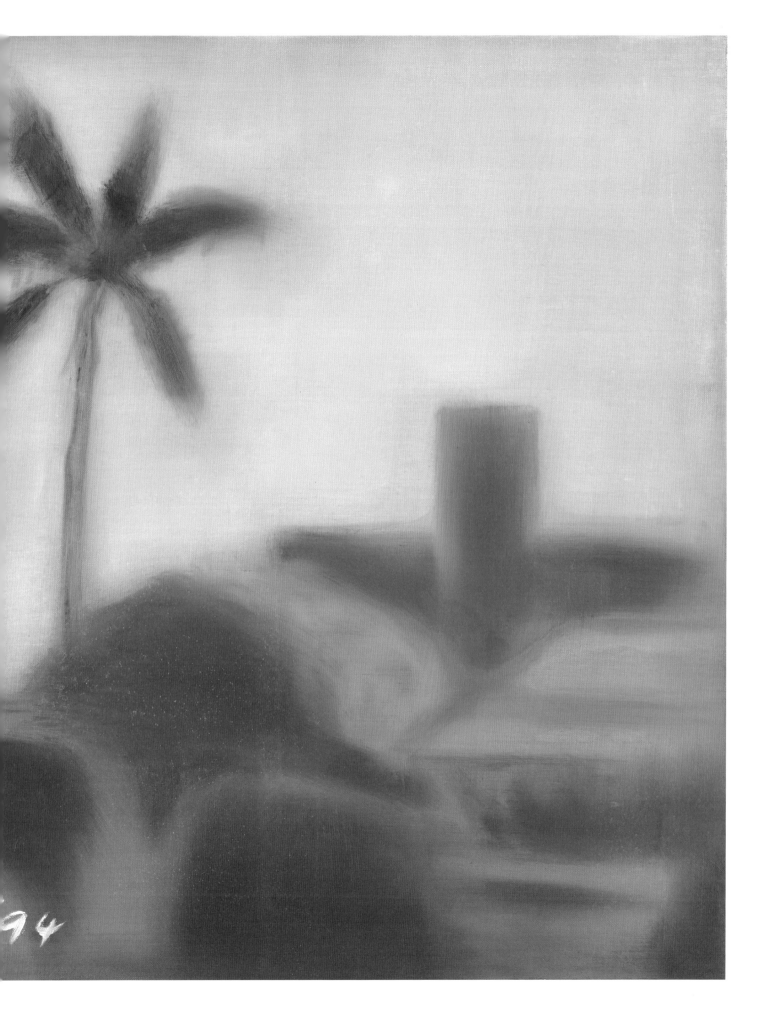

花蓮海灘風景 Hualien Seashore
1993
布面油彩 oil on canvas
74 x 74 cm

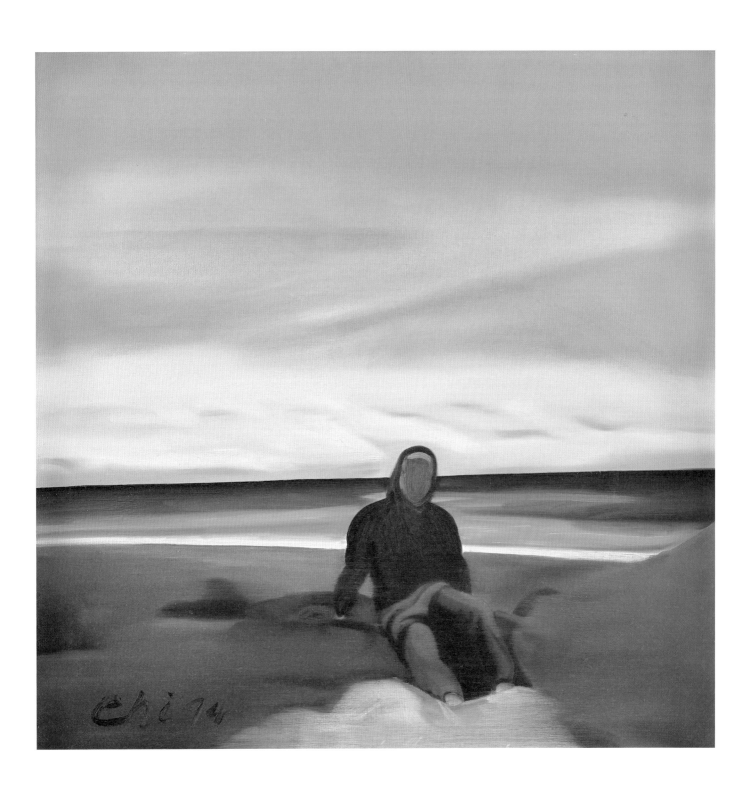

夢裡的沙河之 1
Rivers in Dreams
1980's
銀鹽相紙 gelatin silver print
image size 22.8 x 35.2 cm, paper size 30.5 x 40.6 cm

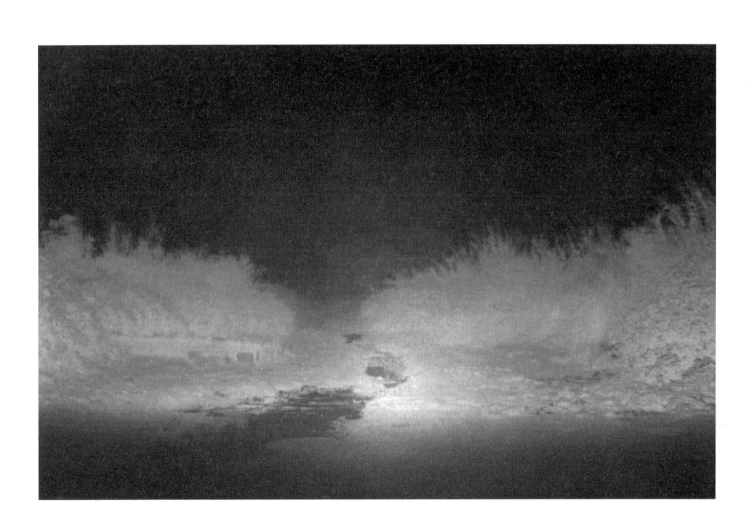

晨河
River in the Morning
1980's
銀鹽相紙 gelatin silver print
image size 25.4 x 37 cm, paper size 30.5 x 38 cm

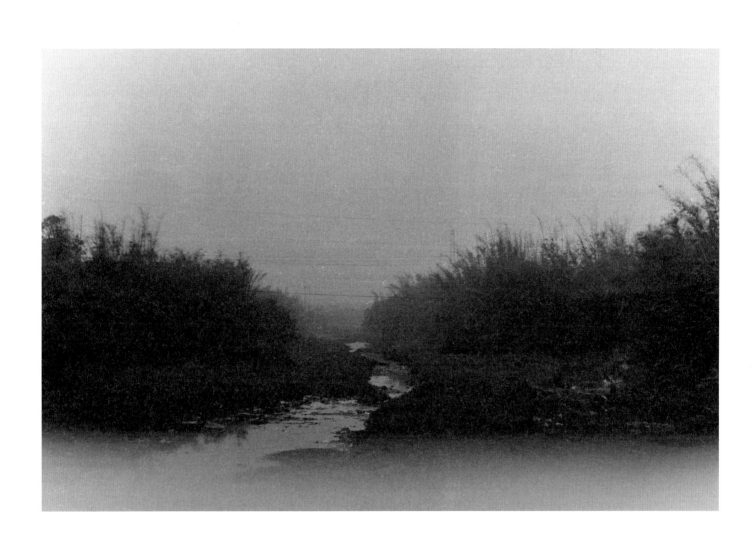

瓦屋
Tile House
1980's
銀鹽相紙 gelatin silver print
image size 18.6 x 29.6 cm, paper size 25.4 x 30.5 cm

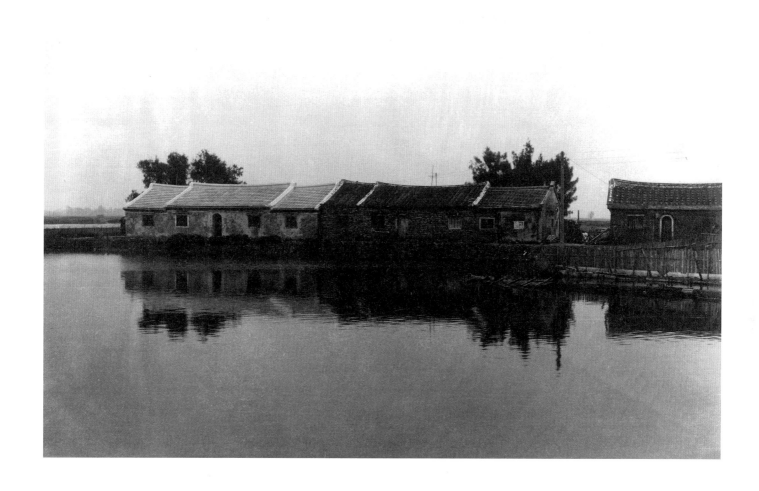

海灘小女（家族之2）
Daughter at Sea (Family II)
1980's
銀鹽相紙 gelatin silver print
image size 24.3 x 34.8 cm, paper size 30.5 x 40.6 cm

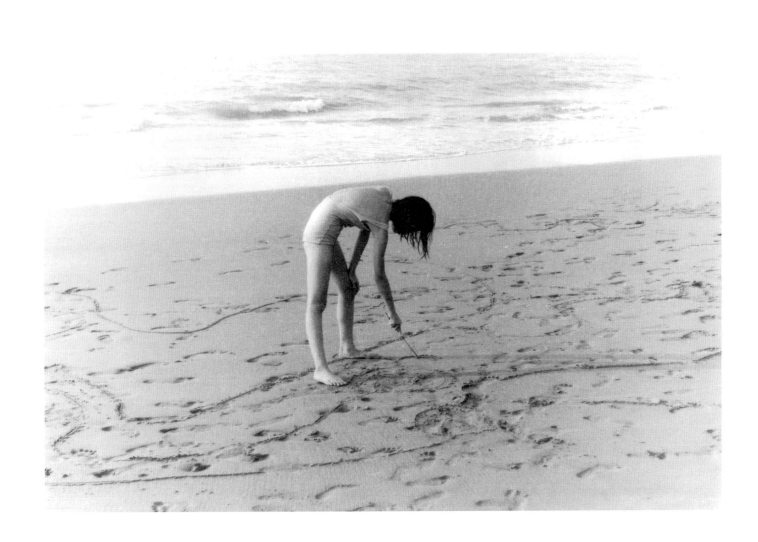

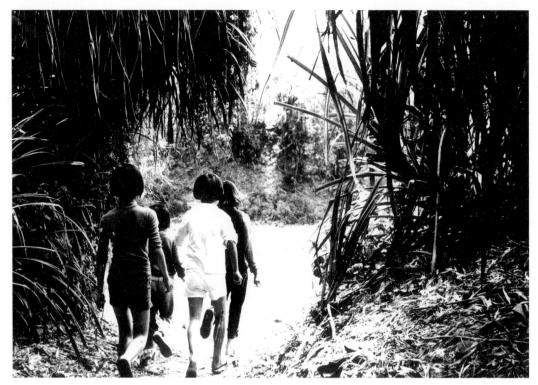

童年之 1
Childhood I

童年之 2
Childhood II

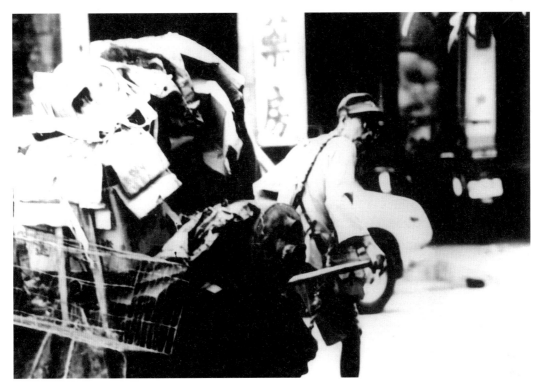

收破爛者之 2
Scavenger II

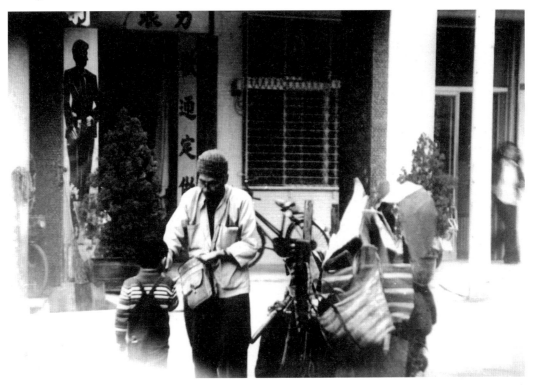

收破爛者之 3
Scavenger III

1980's
image size 12.1 x 17.2 cm, paper size 13 x 18 cm
為《重回沙河》原稿

天聽
Hearing
1980's
銀鹽相紙 gelatin silver print
image size 12.3 x 18 cm, paper size 13 x 18 cm

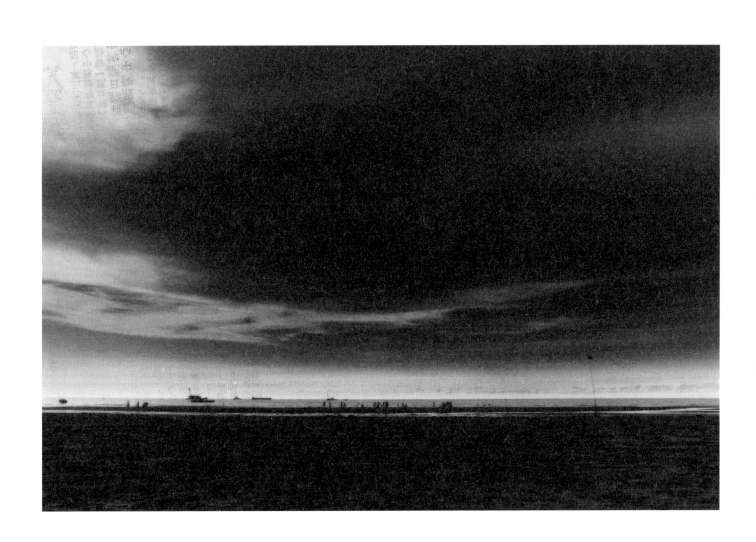

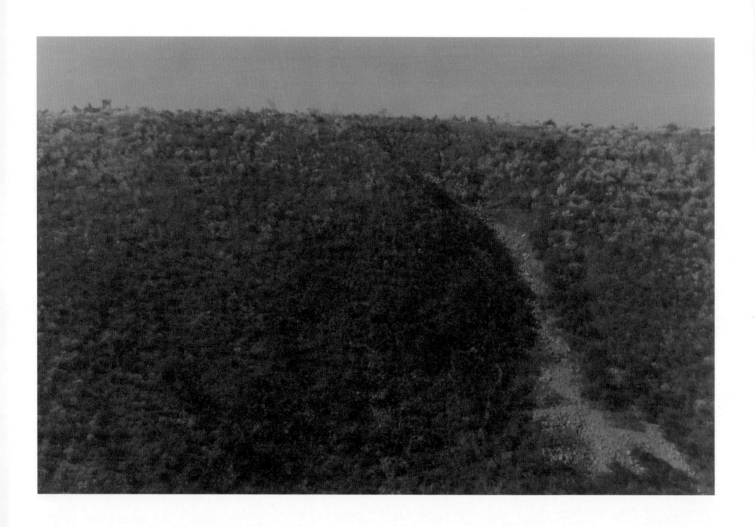

無題
Untitled
1980's
銀鹽相紙 gelatin silver print
image size 20.1 x 30.4 cm, paper size 25.4 x 30.5 cm

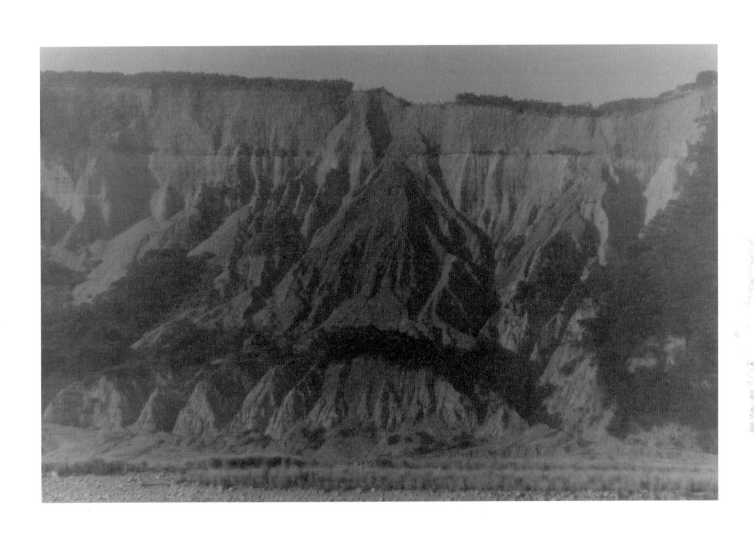

無題
Untitled
1980's
銀鹽相紙 gelatin silver print
image size 20.1 x 30.4 cm, paper size 25.4 x 30.5 cm

裸身
Naked
1980's

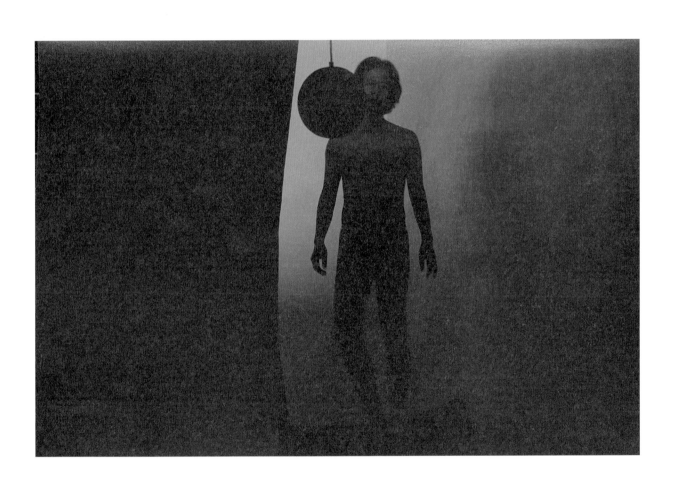